MW00782109

Images of Modern America

SIX FLAGS
GREAT ADVENTURE

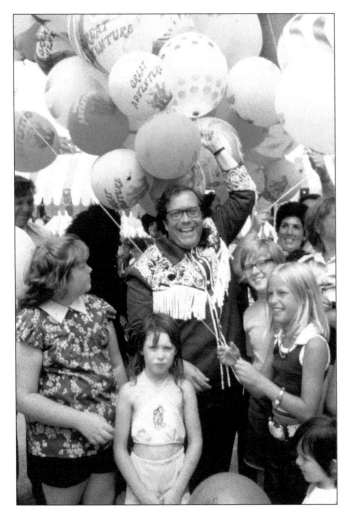

Great Adventure was the brainchild of Warner LeRoy, a colorful and unique man who loved to create spectacles. He had a vision of Great Adventure being as big and as elaborate as Walt Disney World but with truly unique, larger-than-life elements that would be unlike anything else in the world. (Courtesy of GreatAdventureHistory.com.)

FRONT COVER: When Great Adventure opened in 1974, it offered a full day of fun in the beautiful woodlands of New Jersey. Special care was take to preserve as many trees as possible in the theme park, which was appropriately named the Enchanted Forest. The layout of the park took advantage of its natural surroundings, including its peaceful waterways, scenic lake, and the park's glorious canopy of old-growth trees. (Courtesy of GreatAdventureHistory.com.)

UPPER BACK COVER: Fearless riders brave the 415-foot free fall on Zumanjaro: Drop of Doom. (Courtesy of Six Flags Great Adventure.)

LOWER BACK COVER (from left to right): Safari Off Road Adventure explorers travel through all types of rough terrain; Hocken Swipette enjoys a ride aboard the Carousel; high-speed aquatic stunts entertain audiences at the Lethal Weapon Water Stunt Spectacular. (All, courtesy of Six Flags Great Adventure.)

Images of Modern America

SIX FLAGS
GREAT ADVENTURE

HARRY APPLEGATE
AND THOMAS BENTON

ARCADIA
PUBLISHING

Copyright © 2016 by Harry Applegate and Thomas Benton
ISBN 978-1-5316-9849-2

Published by Arcadia Publishing
Charleston, South Carolina

Library of Congress Control Number: 2015955762

For all general information, please contact Arcadia Publishing:
Telephone 843-853-2070
Fax 843-853-0044
E-mail sales@arcadiapublishing.com
For customer service and orders:
Toll-Free 1-888-313-2665

Visit us on the Internet at www.arcadiapublishing.com

This book is dedicated to my father, Harry Applegate, and in memory of my mother, Lillian Applegate, who both in the summer of 1974 took my family to the newly opened Great Adventure and started my lifelong admiration for this park.

—Harry Applegate

Thank you, to my husband Brian, who indulged my love of theme parks and let me follow my dreams. I couldn't do it without you.

—Thomas Benton

CONTENTS

ACKNOWLEDGMENTS

Thank-yous go to the entire management and staff of Six Flags Great Adventure for their invaluable cooperation and access to their collections of press releases, photographs, and memories. Special thanks go to park president John Fitzgerald for his support in keeping the park's history alive and to Kristin Siebeneicher, Kaitlyn Pitts, and Paul Gould for supporting this project and for answering countless inquiries. A big thanks is extended to Dory Oswald, for allowing us to expand our research resources and for giving guests an opportunity to relive their treasured Great Adventure memories at the park, and to Ken Schinkel, who afforded us his time and materials so we could put together additional pieces of the Great Adventure history puzzle.

And last but not least, thanks go to all our members at GreatAdventureHistory.com and the countless Great Adventure employees, both past and present, who help us remember and reflect upon all our favorite things from this wonderful park.

Unless otherwise noted, all photographs courtesy of Six Flags Great Adventure.

Six Flags and all related indicia are trademarks of Six Flags Entertainment Corporation®,™, and ©2016.

Looney Tunes and all related characters and elements are trademarks of and ©Warner Bros. Entertainment Inc.

Batman, Superman, Justice League, and all related characters and elements are trademarks of and ©DC Comics.

INTRODUCTION

Jackson Township, New Jersey, was a group of small villages set in virgin forests and farmland in the early 1970s, with a population of less than 20,000. The quiet area was an ideal location for development, with its natural beauty and proximity to both New York and Philadelphia, which were easily accessed via the nearby New Jersey Turnpike, Garden State Parkway, and the brand-new Interstate 195. The town, which had been a big producer of blueberries and other produce, was a quiet place filled with lakes and streams running through the woods and a beautiful location to camp, fish, and hunt.

One of Jackson's most famous citizens was Stanley Switlik, a man who made a small fortune manufacturing parachutes for the military. He owned a large tract of land in Jackson, filled with forests, lakes, and streams, where he and his family lived. Part of the property was used by the Girl Scouts as a camp and named for his wife, Wanda.

Just 50 miles away in New York City, a colorful man with a lineage of Hollywood royalty had big dreams for creating a spectacular entertainment experience. Warner LeRoy was the son of Mervyn LeRoy, director of *The Wizard of Oz* and many other major films, and as a child growing up on soundstages, he saw that any dream could come true. He wanted to create something spectacular and unlike anything else in the world. To do this, he wanted a beautiful natural setting with lots of room to build everything he could imagine but still close to the huge population centers. His researchers found the Switlik land in Jackson, and made a deal to purchase the huge tract of land from the family to create Great Adventure.

Warner LeRoy had teamed up with the Hardwicke Company, a group that had built safari parks previously, and developed plans for Great Adventure. Designs were made for a complex of parks and resorts that would rival Walt Disney World in scope and offerings, with the overall name of the complex being Great Adventure. Every aspect of the project was designed to be the biggest and best of its kind in the world.

The plans for Great Adventure included three separate theme parks filled with amazing rides, shows, and attractions; the world's largest safari park; an enormous sports complex; a huge camping and nature area; a shopping area like no other; hotels; restaurants; and a network of transportation to tie it all together. The plans for the park were so ambitious that funding for construction was just not feasible with the capital available.

Plans for Great Adventure moved forward with the Wild Safari park and a scaled-down version of the Enchanted Forest theme park as part of the initial build-out. The Wild Safari park would still be the world's largest drive-through animal reserve outside of Africa. The Enchanted Forest combined many of the elements of the three theme park concepts, creating a "best of" park and even including some of the aspects of the proposed shopping district.

Though the theme park concepts were condensed into a single park, many of the most amazing elements carried over from the previous designs. The overall design of the Enchanted Forest still had larger-than-life and record-breaking aspects that would make it stand out as someplace special.

Legal challenges to the park's construction caused delays, and ground breaking did not occur for the theme park until the beginning of 1974. The dedicated work crews gave it their all, and through a herculean effort, Great Adventure was (mostly) ready to open on July 1, 1974—with some of the areas like the Western-themed Rootin' Tootin' Rip Roarin' coming on line shortly thereafter.

Over the past 40-plus years, there have been many changes to the park as ownership and management have evolved, as have the tastes of the public. The biggest change came with Six Flags purchasing the park toward the end of 1977 and upgrading and improving its operations using the company's proven expertise in running regional theme parks. A big part of the Six Flags formula was the constant addition of bigger and more thrilling rides each season, making Six Flags Great Adventure one of the thrill capitals of the theme park world.

Thousands of employees have made a lifetime of memories and friends working at Great Adventure. Some spent their summers working at the park during high school and college and then moved on to other things, but they will always remember the time spent with coworkers who became friends and even family. Some continued their journey with Six Flags Great Adventure, moving up through the ranks and into management, continuing to create a special place where thrills and fun are part of the job.

For visitors, those who came as kids in 1974 now come back with their children and grandchildren, continuing the tradition of fun and excitement decade after decade, generation after generation. For some, it is the rides and roller coasters, while for others, it is the animals and shows. But no matter what the reason, Warner LeRoy's entertainment destination in Jackson, New Jersey, known as Great Adventure, has been making family memories that continue to last a lifetime.

One

COME TOGETHER

Warner LeRoy's imagination was filled with amazing ideas and concepts. The man who created Tavern on the Green and Maxwell's Plum loved to create spectacles and entertain and wanted to create something like no one had ever seen before. In the wake of the opening of Disneyland, there was a construction boom of theme parks around the country, and LeRoy wanted to build his unique vision of what a theme park could be.

With the economic difficulties of the early 1970s, plans for Great Adventure were scaled back for the initial phase. The Wild Safari park and Enchanted Forest theme park were designed and built, with plans to continue with the original designs in the future. The construction of Great Adventure was an amazing feat, with the bulk of the actual construction taking place in under six months.

After the initial build-out of the park and opening to the public, Great Adventure was an unconditional success. Many of the park's attractions were so popular, they had long lines, leading to an additional building spree for the 1975 season, increasing the number of attractions by 50 percent. The crowds were so big, many of the parks facilities and pathways were overwhelmed, so wider pathways and additional facilities were constructed for the sophomore season.

By 1976, the park made an even bigger change, relocating the entrance to the current central location. This improved traffic flow and allowed for even more expansion in the following seasons. Each year, the park would go on to add more rides, and with those additions, the crowds kept growing as well. To keep them coming back, the rides kept getting bigger and faster, often setting records along the way.

For over four decades, Great Adventure has offered a constantly changing lineup of rides, shows, and attractions, making the park's skyline different every season. From ideas, to sketches, to models, to construction, to screams and smiles, a lot of work has gone into making everything come together.

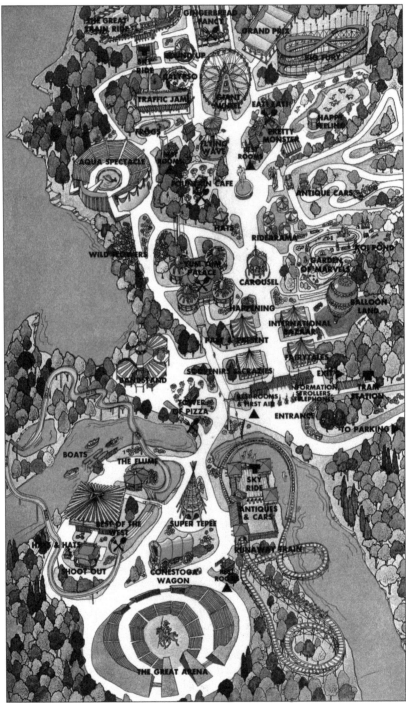

Great Adventure's Enchanted Forest theme park brought an exciting mix of rides, attractions, restaurants, shows, and entertainment to New Jersey. When the park first opened, it was made up of four distinct areas: a fantasy-like Dream Street, the Western-themed Rootin' Tootin' Rip Roarin', an aquatic Neptune's Kingdom, and a Victorian-inspired Strawberry Fair. (Courtesy of GreatAdventureHistory.com.)

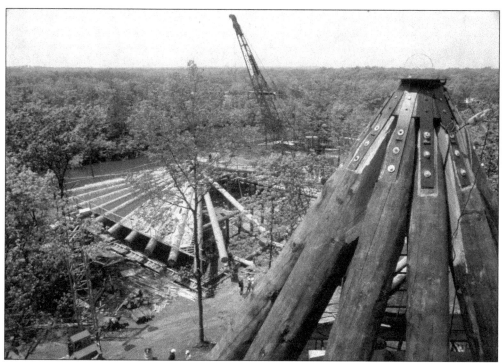

Two of the costliest and challenging structures built as part of Great Adventure's initial construction were Best of the West and the Super Teepee. Both featured enormous logs specially trucked down from the Yukon. The logs had to be cut and shaped for each structure and then carefully placed and attached. Using authentic materials and methods escalated costs and increased construction time, but it created a lasting impact that fiberglass or concrete replicas could not match.

As impressive as the Fort building is, several features never made it off of the drawing boards because of a limited construction window. These include an additional tower behind the Sky Ride station, a covered courtyard for the Runaway Train and Sky Ride queues, observation catwalks around the top of the Fort, and detailed mechanical hatches and smoking cannons surround the fortress.

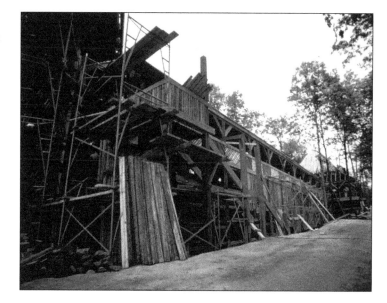

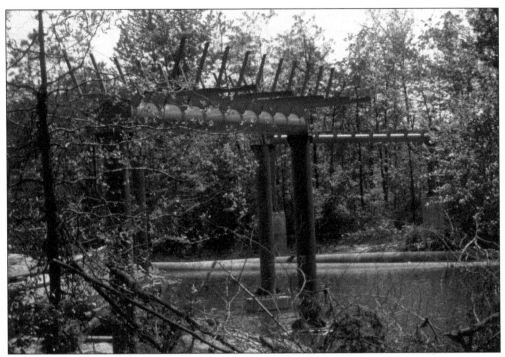

The Flume, later known as the Log Flume, was one of Great Adventure's largest original rides, meandering for over 2,000 feet above both land and water. Even though the construction crews aggressively tackled assembling the ride for an on-time opening, in the end, toilets delayed its introduction on July 1, 1974. Restrooms were added adjacent to the nearby shooting gallery at the last minute, requiring portions of the Flume's trough to be left out until construction equipment could exit and delaying testing of the ride.

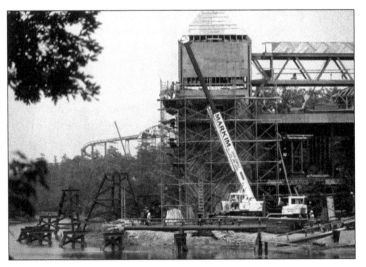

Original plans for the Runaway Train roller coaster included a segment of track through a lengthy underwater tunnel in front of the Fort building. At the last minute, this ambitious feature of the ride was eliminated due to construction-related time constraints and, instead, the ride was reconfigured with the track being installed atop wooden trestles over Lahaway Creek.

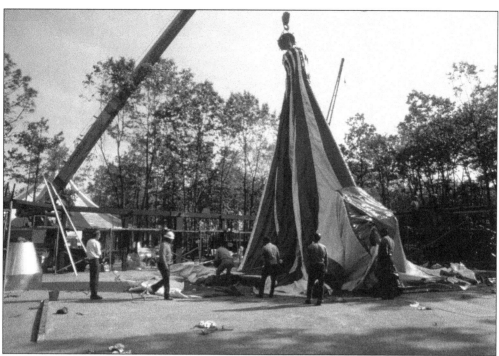

The rides and buildings of the park were all colorful and exciting, standing out amongst the dense forest. Each structure was unique and utilized a wide variety of construction techniques, including roofs made of high-strength canvas, which not only made them eye-catching and bold, but also allowed for quick completion. The entire park was built in less than six months—from ground breaking until opening day.

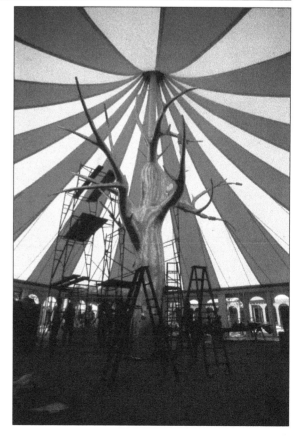

Just inside the park's original main gates, four large tents were erected to serve as the main merchandise centers for guests entering and leaving Great Adventure. Each tent offered different themed shopping experiences, with the interior of the stores open from the floor to the apex of the tents. Drop ceilings were added to all four tents in 1985 to enable the installation of sprinkler heads, necessitating the removal of decorative elements, such as the oversized tree in the center of the yellow tent.

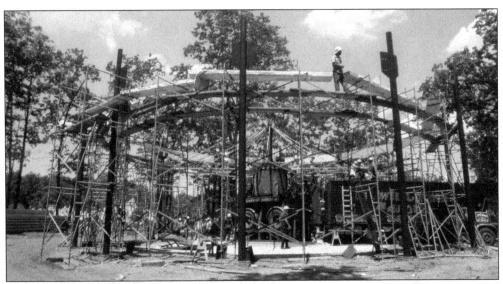

When the Jimmy Williams Famous Steam Roundabout made its way stateside and was installed at Great Adventure in 1974, the ride kept true to its traveling fair heritage. Its assembly included a trailer-mounted center hub supported on four large over-the-highway tires. The ride, which originated in England, even included a boiler plate emblem of the royal coat of arms of the United Kingdom.

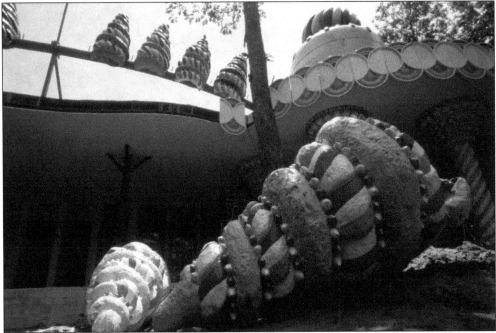

The Yum Yum Palace's ice cream and candy sculptures were all prefabricated off-site and trucked to the park for installation above, around, and inside this one-of-a-kind structure. Due to an abbreviated construction schedule, two of four large, corner ice-cream features were left off the building, with only the two front sundaes put in place. Even though the steel framework was installed on the roof and the sculptures were readied for installation backstage, the rear embellishments never materialized.

14

Several hundred thousand flowers were planted throughout the Enchanted Forest by opening day, resulting in a welcoming environment that was awash with color. In addition to flower beds that lined the walkways and surrounded the rides and shops, other areas like the Woodland Gardens and Happy Feeling petting zoo were populated with lush floral displays. Over 40,000 flower bulbs were used in the Garden of Marvels miniature village attraction alone.

Taken from atop the Garden of Marvels mountain range, this image shows the walkways and waterways of the miniature land coming together as opening day approaches. The colorful tops of two "umbrella rides" are visible in the distance as part of Great Adventure's original kids' area, Ride-A-Rama.

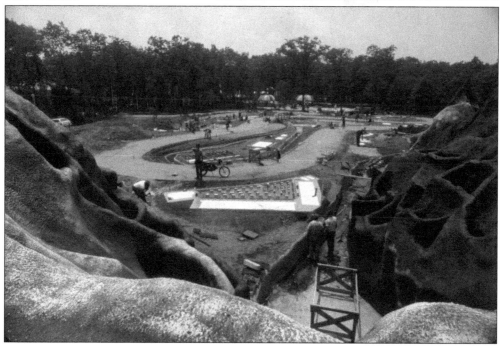

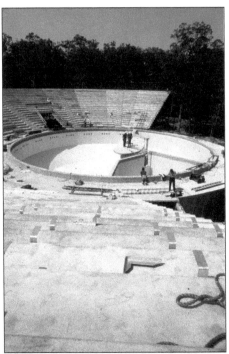

The 3,500-seat Aqua Spectacle stadium was built on the banks of Switlik Lake as a home for the park's dolphin and diving shows. At its center was an 80-foot-diameter pool holding 430,000 gallons of salt water that was produced using salinization and filtration equipment located under the arena's bleachers. The stadium changed names in 1995, becoming Fort Independence, and was demolished during the 2015 season for the installation of the Total Mayhem coaster.

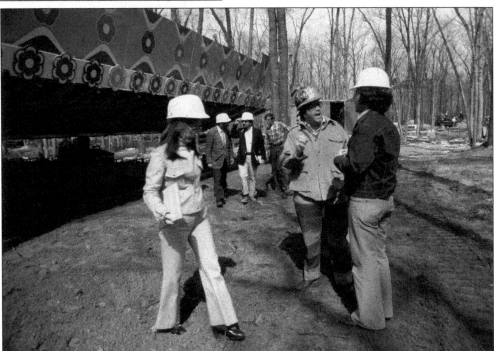

Great Adventure creator and designer Warner LeRoy (in gold hard hat) was extremely anxious to see his dream come true and was often on hand during the construction process. LeRoy is seen here with his staff near the newly installed Traffic Jam bumper cars in the Strawberry Fair section of the park. Most of the portable-type fair rides were installed even long before the first concrete trucks arrived on-site.

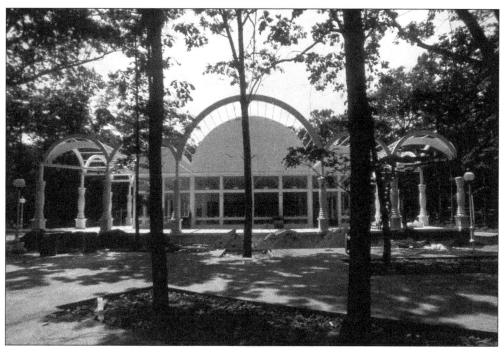

As pictured, the Gingerbread Fancy restaurant looks rather dull before the installation of its wrought iron–like highlights containing thousands of tiny lights positioned above its wraparound terrace. These were added further along in the construction timeline; however, similar trim was omitted from the nearby cable car station due to budget cuts, and it still looks plain today when compared to this elaborate restaurant.

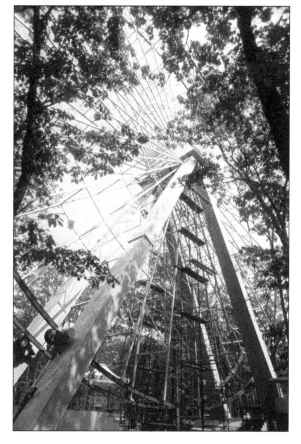

Standing 150 feet tall, more than twice the height of the surrounding forest canopy, the Giant Wheel was the Enchanted Forest's tallest attraction to be installed during the initial construction of 1974. The wheel was brought to New Jersey from Europe, where rides often travel between fairs. Instead of the wheel being firmly anchored with concrete footings, steel boxes disguised as planters along the sides of the legs hold the ride in place.

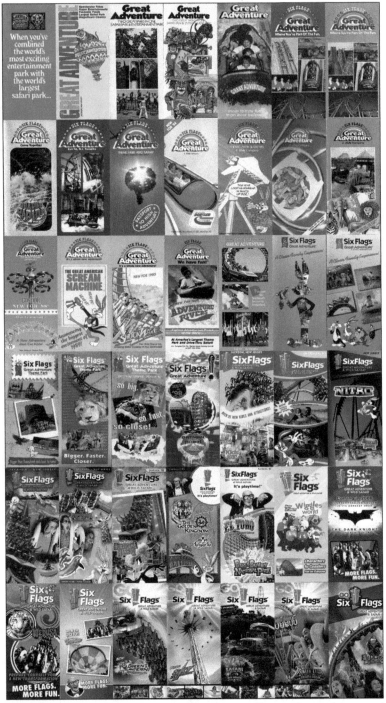

The park's initial construction prior to opening was just a small part of everything coming together at Great Adventure. For more than four decades, guests have been greeted at each season opener with new rides and attractions that did not just magically appear, but instead were selected to appeal to the park's New Jersey audiences. This is a composite image of every pamphlet used from 1974 to 2015 to promote all the new additions through the years.

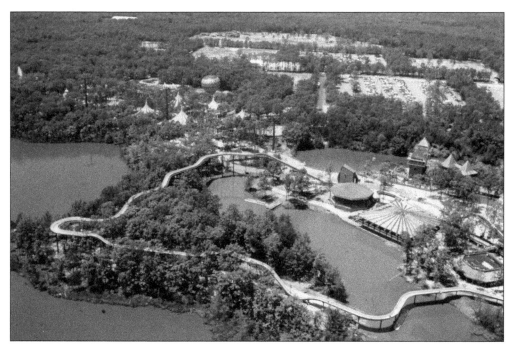

Construction of Great Adventure continued at a frantic pace, leading up to a special sneak preview for invited guests on June 30, a general opening on July 1, and the grand opening on July 4, 1974. Even though the park gates opened on time, numerous attractions—like most of the Rootin' Tootin' Rip Roarin' section—would not be complete for several additional weeks.

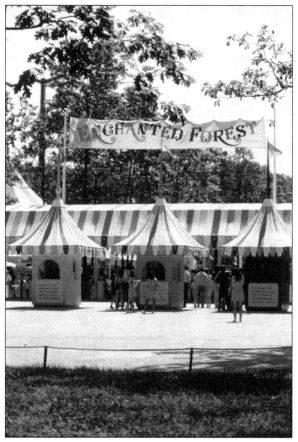

Initially, the name *Enchanted Forest* was synonymous with the theme park, with the combination of the theme park and Wild Safari park being called Great Adventure. The original entrance gates were located near the four tents, and as guests entered the colorful gateway, they would be drawn farther and farther into the park—with the Carousel, Fountain, and Giant Wheel all looming larger and larger in the distance. (Courtesy of GreatAdventureHistory.com.)

For the 1974 season, Great Adventure experienced many growing pains, with crowds exceeding some expectations. One of the longest lines in the park was for the Log Flume, where waits exceeded several hours on most days. Queue bars, which had been installed for waiting guests, proved inadequate and lines often wound around the nearby pathways in the hot sun.

Even the highest-capacity rides, like the Sky Ride, had long lines filling their entire queues and beyond. Before the end of the first season, it became very apparent that additional ride, restaurant, and restroom capacity was needed, and plans were put in place for major expansion.

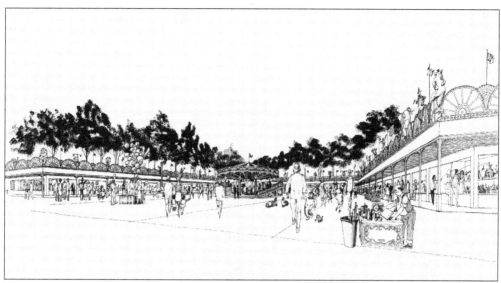

This rendering shows the original plan for Fortune Festival, the park's original games area, built for the 1975 season. At the center of the complex was the Rodeo Switchback Gondola ride, an antique English fair ride purchased along with the Carousel. Installation of the gondola was actually delayed until 1977, and the attraction only lasted one season due to issues with the nearly 100-year-old ride.

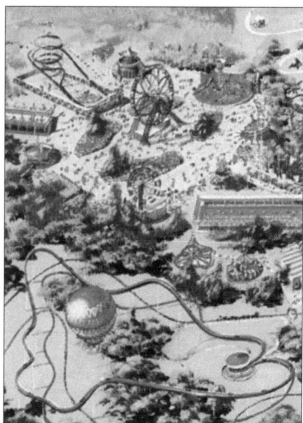

The boundaries of the Enchanted Forest were expanded during the first off-season as a second flume ride, the Hyrdo Flume, and an entire new section of the park, Fun Fair, were added for 1975. Fun Fair featured eight new rides to challenge the park's thrill-seeking guests and lessen waiting times with their added capacity. (Courtesy of GreatAdventureHistory.com.)

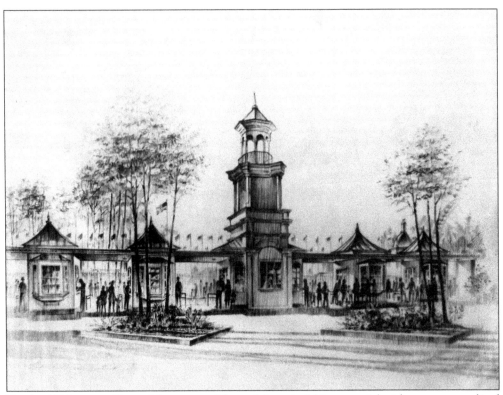

For the 1976 season, Great Adventure celebrated America's bicentennial with a new centralized entrance plaza replacing the original entrance near the four tents. The new Liberty Court area offered Colonial-themed ticket booths and entry gates. Just inside the park, an area known as Avenue of the States featured patriotic-style buildings and the flags of all 50 states flying high. (Courtesy of GreatAdventureHistory.com.)

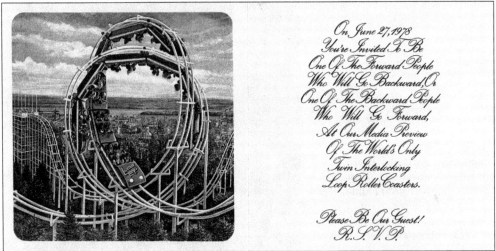

On June 27, 1978
You're Invited To Be
One Of The Forward People
Who Will Go Backward, Or
One Of The Backward People
Who Will Go Forward,
At Our Media Preview
Of The World's Only
Twin Interlocking
Loop Roller Coasters.

Please Be Our Guest!
R.S.V.P.

This media invitation complete with original artwork from 1978 announces the arrival of Lightnin' Loops, one of the first looping roller coasters in the world at the time. The ride heralded the acquisition of Great Adventure by Six Flags, the leader in thrilling themed entertainment in the United States, which purchased the park in the autumn of 1977. (Courtesy of GreatAdventureHistory.com.)

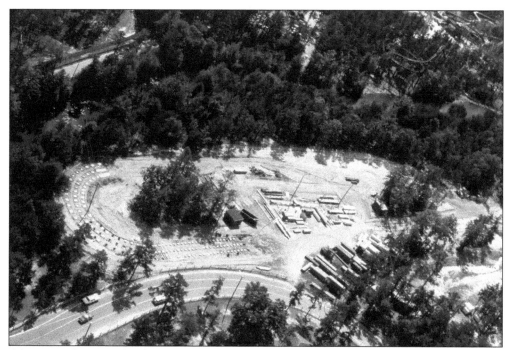

After seeing how popular they were in its other parks, Six Flags decided to add a huge new wooden racing coaster to the park in 1979. Rolling Thunder would be constructed between the banks of Lahaway Creek and the park's expansive parking lot. Tree clearing started in 1978, and the massive wood-assembly project continued through the end of spring 1979, ultimately opening in June of that year.

Added in 1981, Roaring Rapids occupied a 5.5-acre plot of land, which required the excavation of more than 20,000 cubic yards of dirt and the addition of 3,500 cubic yards of concrete. Four sets of rapids were installed to soak guests with whitewater action. From start to finish, the water grade differed by 12 feet, requiring conveyor lifts to get the rafts back to their starting elevation.

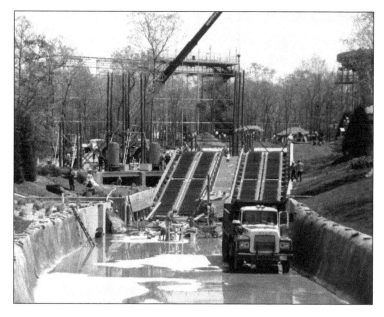

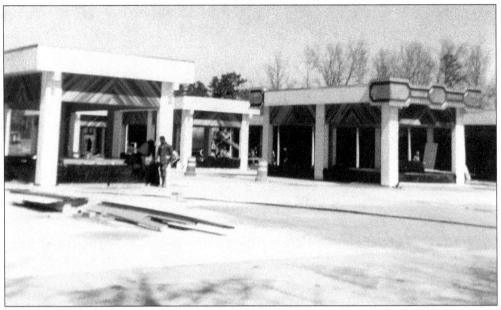

The park's main game center, Fortune Festival, was replaced by a larger complex of games stands in 1982 and was renamed Goodtime Alley. Unlike the U-shaped original arcade, the new facility was open-ended, which allowed access to the area behind the arcade, where the park focused all its expansion plans over the next several seasons. (Courtesy of GreatAdventureHistory.com.)

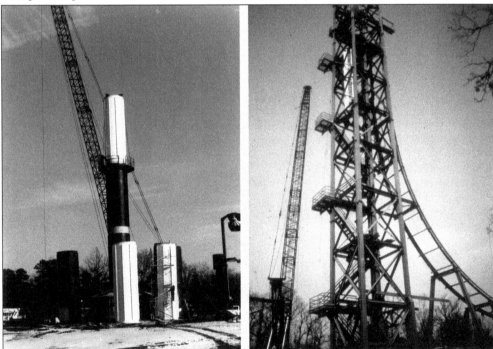

The 1983 season was a dream come true for park-goers, as multiple new attractions were added, including the Parachuter's Perch (left) and FreeFall (right) rides. Both new features allowed guests to experience the sensation of falling vertically to earth, but the parachutes offered a sensation that was much gentler and kinder than the force-inflicting FreeFall drop.

In 1989, Six Flags Great Adventure added its first major roller coaster in 10 years. The Great American Scream Machine was one of the first coasters in the world to offer seven inversions and was, for a brief time, the tallest and fastest looping coaster in the world. The patriotic-themed ride operated until July 2010, when it was demolished to make way for a more modern scream machine.

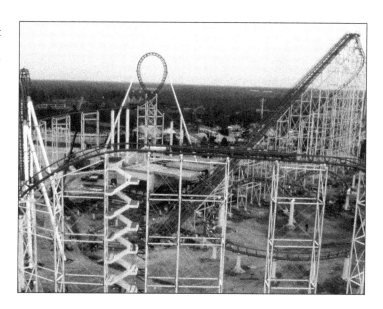

For the 1991 season, the park added a new section called Adventure Rivers, themed to the world's greatest rivers. A series of waterslides that utilized inflatable rafts was constructed around two of the park's existing water rides, which were renamed and re-themed to match the new area. Roaring Rapids became Congo Rapids, the Hydro Flume became the Irrawaddy Riptide, and they were joined by the Asian, North American, and African slide towers and the Koala Canyon water play area. (Courtesy of GreatAdventureHistory.com.)

With a new Time Warner management team came a new set of eyes that reconsidered the appearance of everything park-wide, starting with the main entrance signage. Artists and designers offered numerous proposals for nearly every park structure and attraction in an effort to give things a brand-new look.

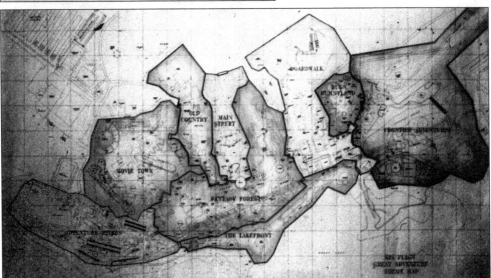

Over the many years of growth and expansion, Six Flags Great Adventure was a theme park that sort of lost its theme. In the 1990s, great efforts were made to remedy the situation by creating nine distinctly themed areas throughout the park, with new buildings, props, names, and in some cases, entirely new attractions.

Elaborate portal signs were installed to mark the entrances of all the newly themed lands in the park. For the first time in the park's history, guests could surround themselves in theming that pulled together neighboring attractions to tell cohesive stories throughout Six Flags Great Adventure.

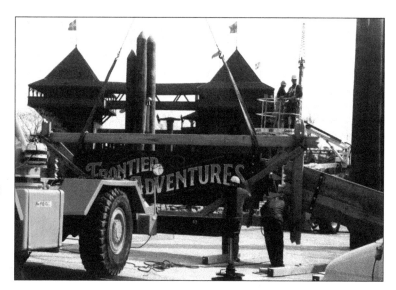

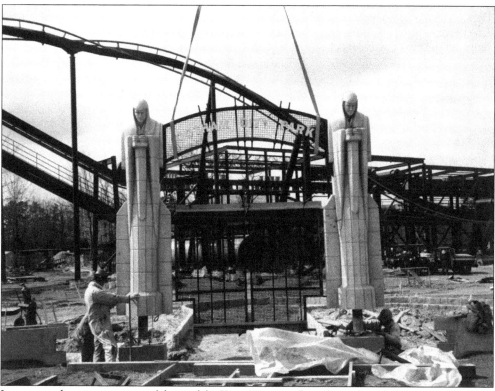

Immersive theming was part of the goal for Time Warner when the park added Batman: The Ride in 1993. A large portion of the attraction's budget was spent on telling a story and setting a mood before the guests even experienced the actual ride. For example, instead of building a simple set of queue bars for riders to wait in, Gotham City Park was constructed, which took guests from lush landscapes to the seedier side of Gotham.

The Looney Tunes Shoppe was added in 1994, occupying the entire left side of a re-themed Main Street entrance area. Not since the entrance was originally positioned near the four Dream Street Tents did the park have as much square footage of selling space at its park gates.

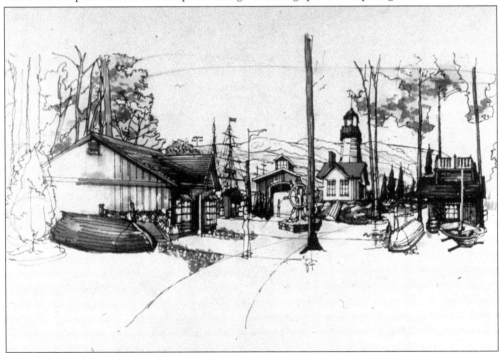

Some of the planned theming updates to the park never quite came to pass. An example of this was the Lakefront's plans for the Aqua Stadium to receive a seascape mural along with a lighthouse and other nautical elements to dress up its plain stucco facade. Instead, the arena was incorporated into an extension of Main Street and renamed Fort Independence.

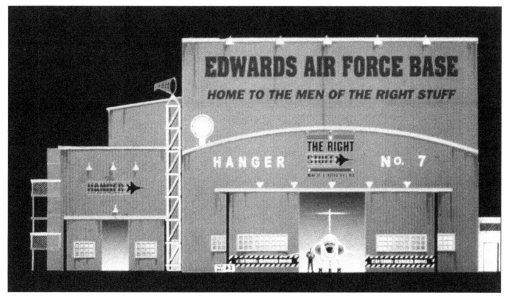

One of the most unique attractions added to the park during the Time Warner era of ownership was the Right Stuff Mach 1 Adventure. The company looked to the theme parks to help cross promote its movies, TV shows, and other properties, and the Right Stuff was one of the first and most successful examples of the synergy Time Warner was creating. Here, the rendering shows the elaborate hangar facade created to house the immersive attraction.

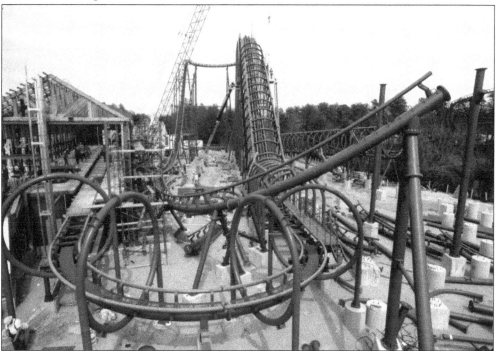

For 1995, Six Flags purchased the Viper coaster as a prototype from the Japanese manufacturer TOGO and made cosmetic modifications like adding rings around the majority of the track, creating a snake-like look. The roller coaster featured a heart line spiral maneuver reminiscent of the Ultra Twister—another TOGO creation, installed in 1986 on the same ride site.

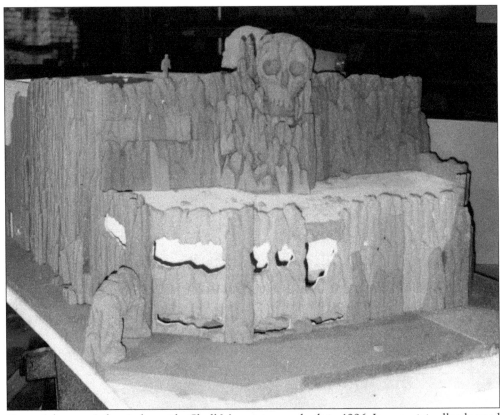

Great Adventure's first indoor ride, Skull Mountain, was built in 1996. It was originally planned as a roller coaster themed to the Warner Bros. movie *Gremlins*, but park designers instead opted to build a 65-foot-tall, skull-topped "mountain," pictured here in model form, next to the popular Adventure Rivers section of the park. (Courtesy of GreatAdventureHistory.com.)

All the extra attention to details equated to extra turnstile clicks, and Six Flags Great Adventure was seeing record attendance numbers. As a result, several smaller flat rides, like the Enchanted Tea Cups, were added to increase park capacity and make guests' visits more enjoyable.

Originally planned for a 1997 introduction, the official opening of Batman & Robin: The Chiller was rescheduled for the spring of 1998 after only having operated sporadically during its first season. The highly sophisticated linear induction motors (LIMs) proved to be a bit of a challenge early on in this 20-story-high contraption, which sent riders racing more than 65 miles per hour both forwards and backwards. (Courtesy of GreatAdventureHistory.com.)

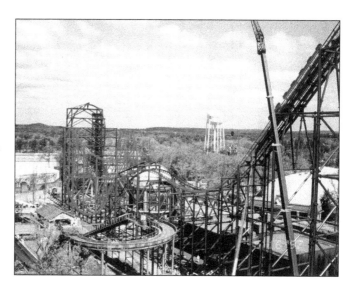

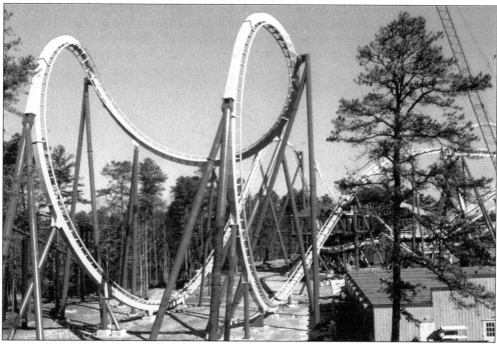

In 1999, Six Flags Great Adventure added more than 25 rides to the theme park in a single season—more rides than were built when the park initially opened in 1974. Three roller coasters made their debuts, including Medusa, the world's first floorless coaster. The new wave of attractions was an all-out assault on waiting as the park declared a "war on lines" and transformed itself into a "Super Park."

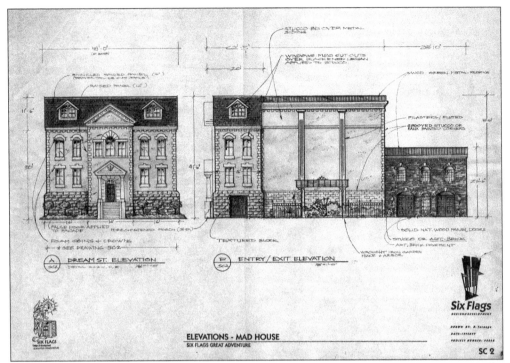

Houdini's Great Escape was the sleeper hit of the new attraction lineup for 1999. Known in the industry as a Vekoma Madhouse, the ride's stately mansion exterior was erected near the Carousel. Inside this four-story edifice, Houdini performed his ultimate illusion on guests as he made the parlor of his home appear to turn upside down in a series of dizzying special effects.

Originally planned to be located deep inside the park, Superman–Ultimate Flight arrived in 2003 and was constructed in the parking lot just outside the main entrance mall adjacent to the park's original administrative offices. Today's location allows for excellent views of the ride and offers visitors a sense of excitement and anticipation as they hear the screaming flyers gliding by while heading into the park. (Courtesy of GreatAdventureHistory.com.)

After almost a decade of randomly placed attractions, Six Flags Great Adventure unveiled its most aggressively themed additions to the park in 2005 with the introduction of the Golden Kingdom. Occupying 11 acres, this mythical jungle-themed land featured the world's tallest and fastest roller coaster, Kingda Ka; a new children's area, Balin's Jungleland; an extensive tiger show; and an exhibit area named Temple of the Tiger, as well as numerous shops and food outlets.

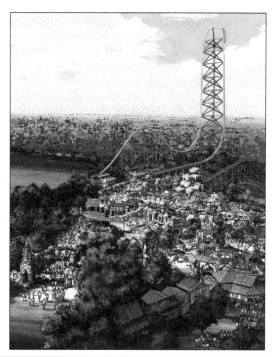

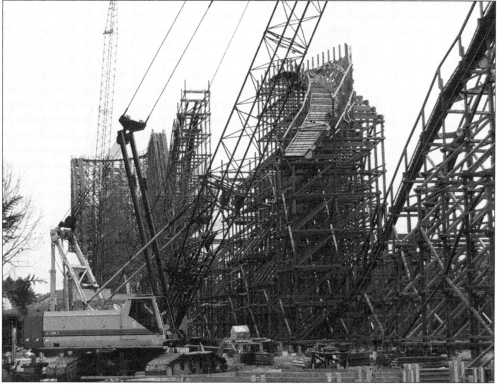

Hot on the heels of the record-breaking Kingda Ka coaster, 2006 saw the addition of the ultimate wooden coaster, El Toro, in the newly themed Plaza del Carnaval, complete with shops, restaurants, and a family ride known as Tango. (Courtesy of GreatAdventureHistory.com.)

After almost 20 years since the removal of Six Flags Great Adventure's original stand-up coaster, Shockwave, Green Lantern joined the park's coaster lineup in 2011. The ride was imported from Six Flags Kentucky Kingdom, where it operated as Chang. With the addition of new theming, which included the jet originally parked outside the Right Stuff Mach 1 Adventure ride, Green Lantern offered exciting new stand-up thrills to the Northeast. (Courtesy of GreatAdventureHistory.com.)

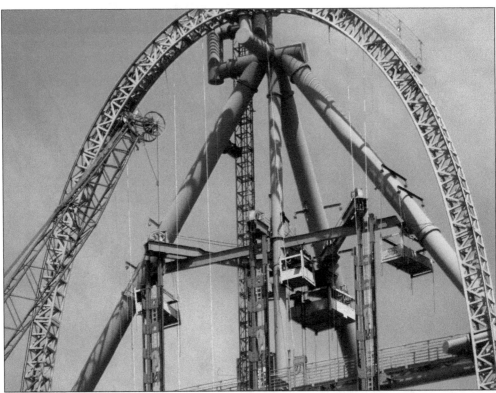

As if having the world's tallest roller coaster, Kingda Ka, was not enough for one park, Great Adventure flexed its thrill-riding muscles once more in 2014 by adding Zumanjaro: Drop of Doom. Billed as the world's tallest drop tower at 415 feet, twice the height of the Statue of Liberty, Zumanjaro made use of Kingda Ka's beefy structural tower as the main support for its 90-miles-per-hour dropping gondolas. (Courtesy of GreatAdventureHistory.com.)

Two

A HECK OF A SHOW

From the opening of Great Adventure in 1974, the park has been known for spectacular shows. The types of productions may have changed with the times, but some of the most popular attractions in the park's history have been its entertainment offerings.

When the park opened, the two biggest attractions in size and capacity were the Great Arena` and the Aqua Spectacle. Both venues combined actors and animals performing in ways never seen in the scale and scope presented at Great Adventure. The Great Arena did multiple shows each day of chariot races, Wild West shows, and even a circus. The Aqua Spectacle alternated high-diving and dolphin shows throughout the day, packing the stadium for each show. On top of those big extravaganzas, music filled the air throughout the park, with several stages showcasing musical acts and troops of costumed characters throughout interacting with guests.

With changes in public tastes, new and innovative entertainment was added while other shows were retired. The Showcase Theatre offered an ever-changing lineup of live stage shows. For many seasons, the Batman Stunt Arena offered a Hollywood-caliber stunt show. The Glow in the Park Parade lit up the streets of Great Adventure with music and lights like nothing else. Through the years, whether it was live actors and actresses, marine life or big cats, fanciful puppets or brilliant fireworks, Six Flags Great Adventure has always put on one heck of a show.

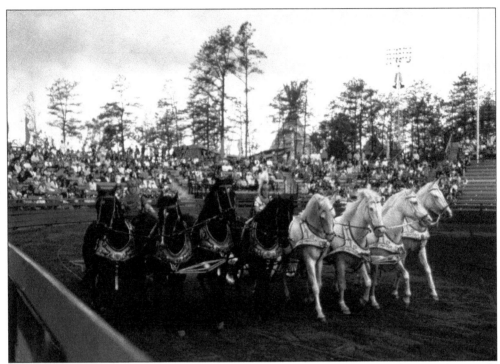

The Great Arena was the park's entertainment capital when it opened in 1974, featuring large-scale thrilling action productions including chariot races, Wild West rodeos, and stylish trick-riding performances. Seating 6,500 people, with additional floor space to accommodate up to 10,000 guests total, the stadium still serves as a major concert venue today.

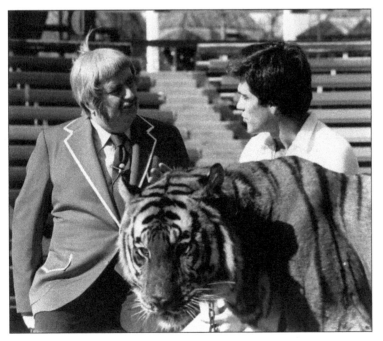

Numerous celebrities have visited Great Adventure—many having done television and radio spots to promote the park. *The Mike Douglas Show* was taped at the park for an entire week during 1975, actor and comedian Jerry Lewis filmed a "Love is a Great Adventure" commercial for 1976, and Captain Kangaroo (left) appeared with the stars of David McMillan's Fabulous Flying Tigers show.

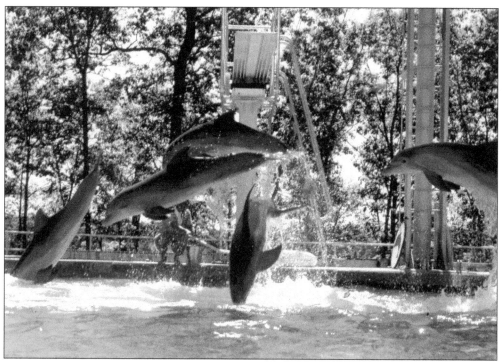

One of the most popular shows at Great Adventure was the Aqua Spectacle's Dolphin Show. In 1974, audiences marveled as a pod of 10 dolphins performed tricks and maneuvers that were often described as breathtaking. Upwards of six dolphin shows (and six diving shows) took place each day, with guests filling the heavily wooded area next to the Yum Yum Palace to wait in line for the next performance.

The view from atop the 100-foot-high dive tower at the Aqua Spectacle was a site very few people got to see. As the finale of the high dive shows, a diver with nerves of steel would climb all the way to the top of the tower and make that plunge to the 16-foot-deep pool down below.

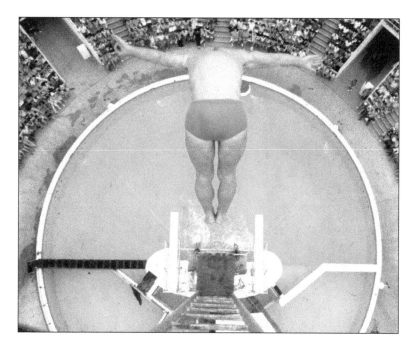

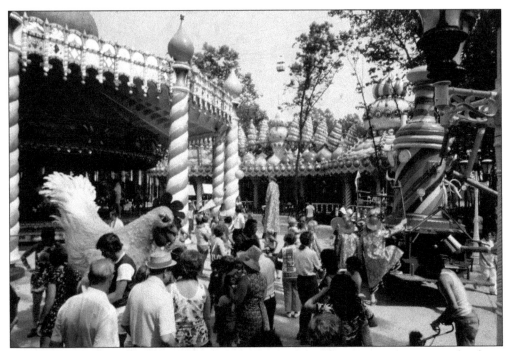

Great Adventure was designed to be alive with sights, sounds, and fun everywhere. Here, the clown fire truck has arrived in front of the 19th-century Carousel and the Yum Yum Palace restaurant. Costumed characters, clowns, and oversized body puppets of every type were found throughout the park, including a gigantic chicken. (Courtesy of GreatAdventureHistory.com.)

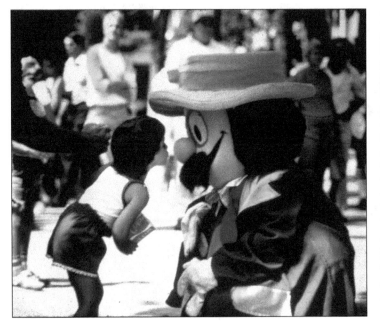

Before the introduction of characters like Pac Man, the Shirt Tales, and the Looney Tunes, Great Adventure had its own cast of characters. Here, Hocken Swipette, the Mayor of Great Adventure, makes the acquaintance of a young guest. He, along with other characters like Sir Wilden Wooley, Flapperz the Clown, Maurice Le Rat, and the Grunge, were unique and somewhat psychedelic creations who roamed Dream Street.

The Bandstand on the Lake was one of the park's original show venues. Initially an open-air venue with canvas roof and minimal stage, it sat right along the edge of the Great Lake, offering a fantastic view as guests listened to bands play. Later, the building received a more permanent roof, as well as a bigger stage with backstage dressing rooms to house more elaborate shows and productions.

Often, local talent was used in the Bandstand on the Lake productions. These talented young performers in colorful costumes offered a mix of musical classics and modern hits interspersed with slapstick comedy and physical feats. Today, the bandstand is part of Bugs Bunny National Park and home to character shows and talent competitions.

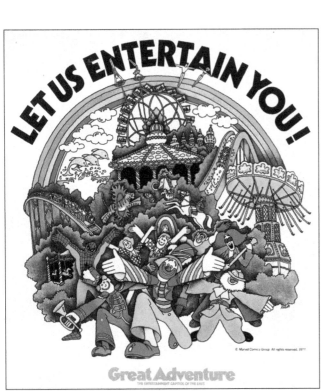

© Marvel Comics Group. All rights reserved. 1977

Great Adventure
THE ENTERTAINMENT CAPITOL OF THE EAST

Great Adventure was known as much for its entertainment offerings as it was for its rides in the early years. For a time, the song "Let Me Entertain You" from *Gypsy* was used in commercials, modified to "Let Us Entertain You." The commercials featured scenes of the clowns, bands, characters, and various entertainment throughout the park. (Courtesy of Dan Inghram.)

A guest favorite from the earliest years of Great Adventure was the Fearless Bauers, a family act of skill and bravery high atop a set of sway poles. The athletic acrobats would climb to the tops of the poles and, using their body weight, sway toward and away from each other, crossing from one pole to the other high in the air above the heads of the audience.

The Great Arena has always been a venue for a wide variety of shows and competitions. In 1976, the television program *Almost Anything Goes* hosted a series of contests between local towns plotting neighbor against neighbor in some good-hearted races. Soon after, this event became the inspiration for the park's annual employee competition, the Fun Olympics.

Some of the stage shows produced at the park were quite elaborate, including this one called *Strictly U.S.A.* Six Flags had a long tradition of creating Broadway-style shows, and when the company acquired Great Adventure, one of the first things it did was add the Americana Music Hall, today known as the Showcase Theatre, to house these kinds of elaborate stage shows.

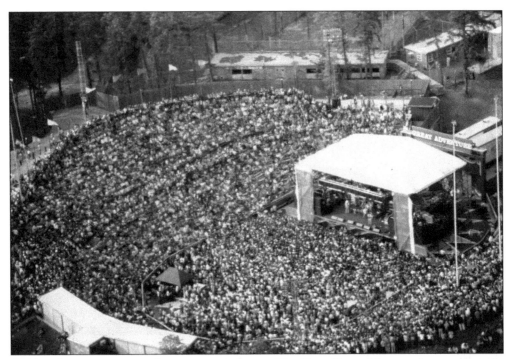

For decades, concerts were always an integral part of Six Flags Great Adventure's entertainment lineup, attracting some of the biggest-name talent with multiple concerts each week. One of the biggest crowds packed the park on May 16, 1981, for a Marshall Tucker Band concert. Not only did the Great Arena, the parking lot, and the theme park reach capacity, but hundreds of guests also parked their cars along Route 537 in an effort to see the show.

One of the most memorable shows at Great Adventure was *Errol Manoff's Fantasy Factory in Magical Movie Moments*, which featured larger-than-life puppet versions of celebrities. The show was performed in the Great Arena in 1982 and moved to the Americana Music Hall in 1983, where specialty lighting and sound effects were more easily executed.

For the 1983 season, Six Flags Great Adventure added the Water Ski Spectacular on the Great Lake along with a massive new grandstand. Preparation for the show took place over the previous winter with the lake being drained for re-profiling and removal of trees stumps for the new skiers and boats, which would soon take to the park's once tranquil lake.

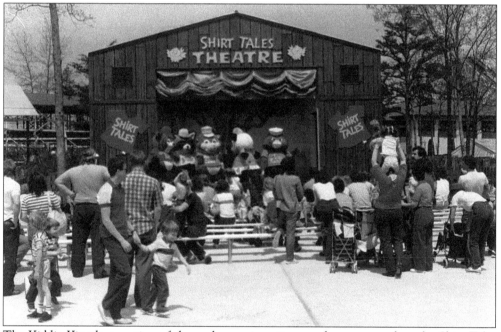

The Kiddie Kingdom section of the park was given its own show venue when the Shirt Tales characters were introduced in 1984. Shirt Tales Theatre went on to become the Looney Tunes Theater in 1985 and then the Bugs Bunny Land Theater in 1988. The theater was removed after the 2004 season to make way for the introduction of the Golden Kingdom the following year.

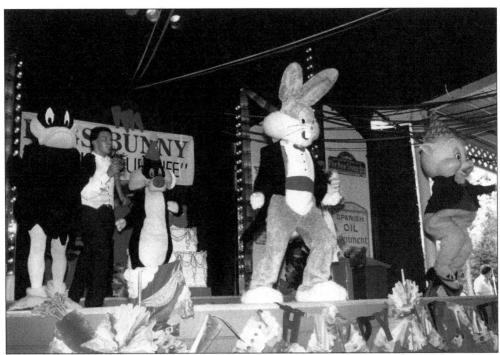

Since 1985, the park has always featured some kind of Bugs Bunny–inspired show, each one celebrating the world's most famous rabbit's career along with the rest of his Looney Tunes friends. The show pictured here is *The Bugs Bunny Birthday Show*, celebrating his 50th birthday in 1990 at the Bandstand by the Lake.

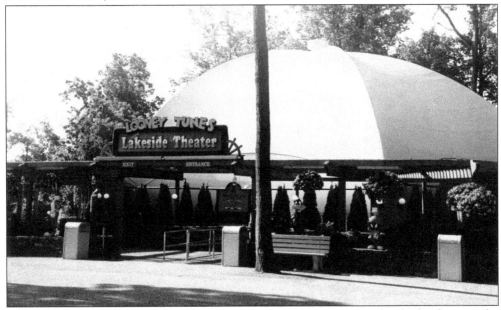

Originally introduced in 1980 as the Adventure Theater Cinema 180, this facility became the Looney Tunes Lakeside Theater in 1995. Inside, the park hosted a meet and greet with some of the Looney Tunes characters, until it was removed after 1998 to make way for Blackbeard's Lost Treasure Train roller coaster.

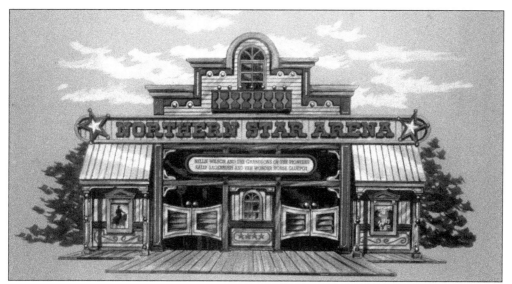

The Great Arena transformed into the Northern Star Arena in 1993 as part of the thematic enhancements made around the park. The former Best of the West area of the park became Frontier Adventures, further playing up the Old West motif, and a new themed portal was designed and installed at the entrance to the arena.

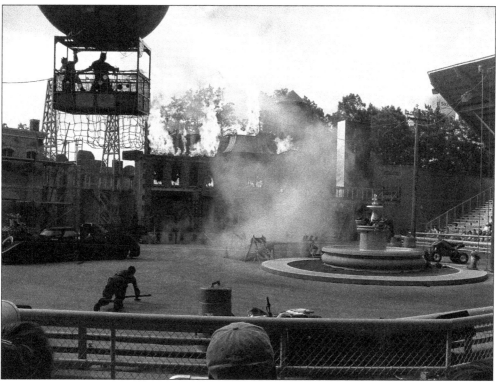

The Batman Stunt Arena was added in 1992 to Action Town, which was later renamed Movie Town. Over the years, the stadium has played host to such Caped Crusader–themed productions as the *Batman Stunt Spectacular*, *Batman Forever Stunt Show*, *Gotham City Carnival of Chaos*, and *Batman vs. Catwoman: Catfight*. (Courtesy of GreatAdventureHistory.com.)

Another unique show only found at Six Flags Great Adventure was the *Lethal Weapon Stunt Spectacular*. This stunt-filled show was performed on the lake where water-skiing shows had been held in the past. The production followed the adventures of Riggs and Murtaugh from the Lethal Weapon movies and featured a series of water stunts, including speedboat and Jet Ski chases and jumps, as well as several pyrotechnics displays.

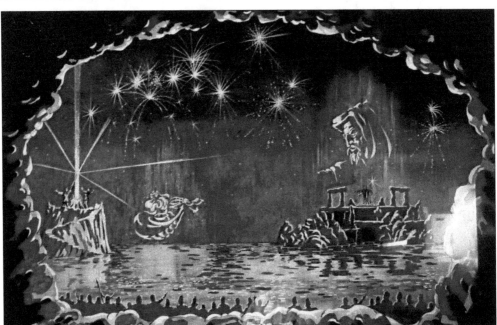

One of the most ambitious shows created for Six Flags Great Adventure was the *Quest for Camelot Nights*. The show was a combination of fireworks, lasers, actors, and water projection screens that told the story of the Warner Bros. animated film *Quest for Camelot*. It was a spectacular show, but it somewhat suffered from guests' lack of familiarity with the movie's story line.

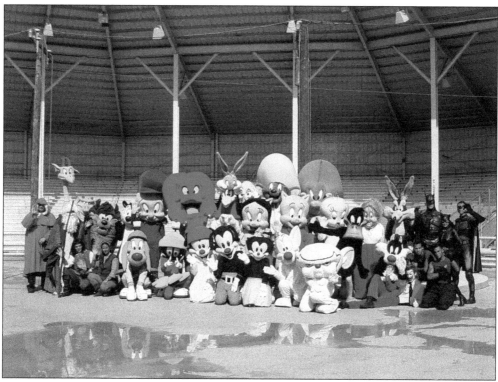

Rarely seen all in the same place, this cast of characters gets together for a group photo in the Batman Stunt Arena. At one point, along with the main Looney Tunes characters, Six Flags Great Adventure also hosted the Animaniacs, Pinky and the Brain, Batman, Robin, Catwoman, the Joker, and various characters from the Warner Bros.–produced animated film *Quest for Camelot*.

From 2005 to 2010, the Golden Kingdom's Temple of the Tiger theater offered a unique opportunity for families to see tigers up close performing natural behaviors to the amazement of onlookers. Between performances, visitors were invited to see the tigers in an enclosed natural environment adjacent to the theater. (Courtesy of GreatAdventureHistory.com.)

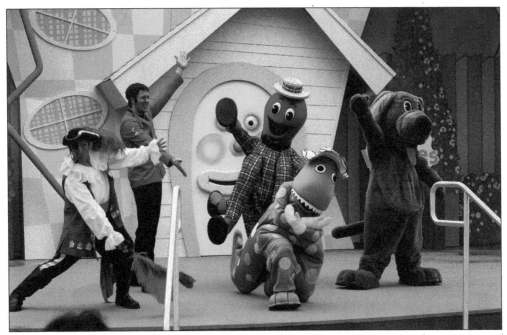

Children of all ages were encouraged to "Get Ready to Wiggle" in 2007, as the zany cast of characters from the hit television show *The Wiggles* had a new home at Wiggles World at Six Flags Great Adventure. The Wiggles theater stage made use of the former rotating loading platform from the park's Hydro Flume, which was removed after the 2006 season.

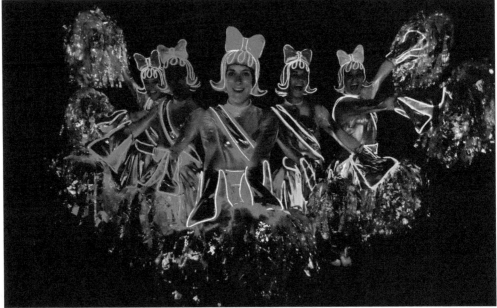

A fan favorite at Six Flags Great Adventure during the summer months from 2008 to 2010 was the Glow in the Park Parade. This nighttime extravaganza lit up the park with colorful costumes and floats. The parade was designed by Goddard Group, creator of signature shows and attractions around the world, and featured an amazing sound track written specifically for the parade by famous Cirque du Soleil composer Benoit Jutras.

Three

A SHORT RIDE FROM GREAT RIDES

The rides of Great Adventure have left an indelible impression on many guests from around the region and even around the world. The park has consistently provided new and exciting experiences each season, often introducing the first, biggest, and best-of-their-kind rides. Many of the attractions now found in nearly every park around the globe were introduced at some point at Six Flags Great Adventure, with the company's ride development team working with manufacturers to create new and exciting experiences.

From the very start, Six Flags has created the perfect balance of rides, attractions, and entertainment, building on the ideas at Disneyland but offering bigger, better, and faster thrill rides as part of the mix. Six Flags Great Adventure offered many people their very first chance to ride a roller coaster that did a complete loop when Lightnin' Loops was added in 1977. The state-of-the-art coaster thrills continued in later years with the tallest and fastest looping roller coaster in the world, the Great American Scream Machine, in 1989; with the introduction of the tallest and fastest coaster, Kingda Ka, in 2005; and once again in 2006, with the fastest and steepest wooden coaster in the world, El Toro.

Be it an extreme thriller, the mildest first-ride experiences, or the smallest kiddie rides, Six Flags Great Adventure has continually offered the best lineup of rides for the whole family since the park opened in 1974.

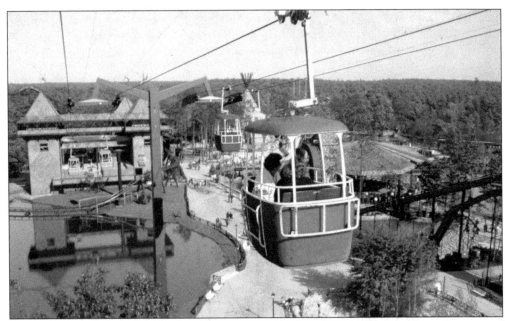

For many guests, their first sight of the Rootin' Tootin' Rip Roarin' Western-themed section of the park was from the Sky Ride as it approached the massive Fort. Everything in the themed area was super-sized, from the Fort, to the Super Teepee, to the Conestoga Wagon—all alongside the world's largest Log Flume and the massive log structure of the Best of the West restaurant. (Courtesy of GreatAdventureHistory.com.)

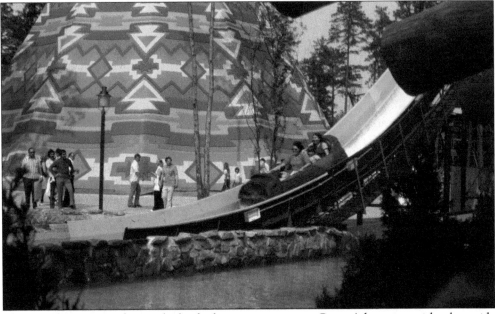

The Log Flume was without a doubt the biggest sensation at Great Adventure, with a long ride above the trees with several exciting drops culminating in its biggest splash at the end of the ride, careening past Best of the West restaurant diners. The Flume's record-setting popularity inspired a second flume the following season, as well as numerous other water rides in the years to come. (Courtesy of GreatAdventureHistory.com.)

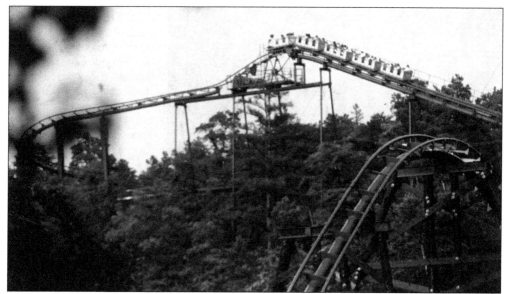

Great Adventure's first roller coaster, the original Runaway Mine Train, continues to thrill riders more than 40 years later. The colorful trains offered many guests their first "big roller coaster ride" when they were kids, and they are able to return as adults for their children's first roller coaster ride. (Courtesy of GreatAdventureHistory.com.)

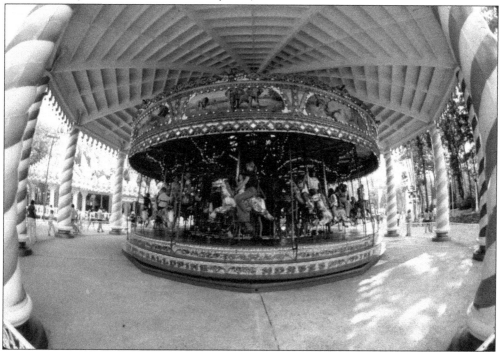

The oldest ride at Great Adventure was the 19th-century English carousel. The steam-powered Carousel was built in 1881 and was purchased by Great Adventure and set up under an elaborate pavilion. The ride was converted from steam power to compressed-air power for safety, then converted again to electric power for greater reliability and ease of maintenance. Being an English carousel, it runs clockwise, while American carousels run counterclockwise.

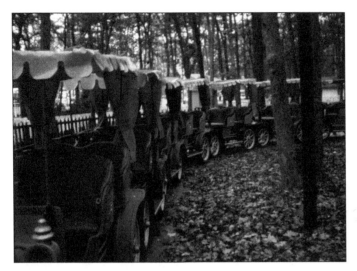

One of the park's original—and very short-lived—attractions was the Antique Cars ride. The electric-powered cars made a slow-paced circuit through a wooded area for only two seasons before being removed to make way for the park's new central entrance in 1976. There were plans to relocate the ride to the area beneath the Log Flume in 1976, but they never panned out, and the cars never returned to the park.

The Flying Wave was one of Great Adventure's original attractions located in the Strawberry Fair section of the park. For the first few decades of operation, the ride did not have a "Flying Wave" sign outside its entrance, and as a result, most guests simply referred to this twirling machine as "the Swings." The ride was removed at the end of the 2007 season, and the site became home to the SkyScreamer in 2012.

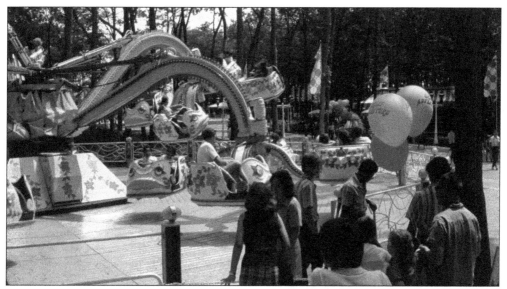

The Pretty Monster, the first of Great Adventure's octopus-style rides, opened with the park in 1974. While most octopus rides were designed to be menacing looking, Pretty Monster was bright and colorful with a floral motif painted on the ride's main structure as well as on the individual cars. After the 1975 season, it was moved to a new site next to the Yum Yum Palace, where it became the Dream Street Dazzler. (Courtesy of GreatAdventureHistory.com.)

The Super Round Up ride was the first ride to arrive, and though it was a type of attraction found at many parks and carnivals, the colorful paint scheme and lighting made it fit the aesthetics of Great Adventure. Initially positioned next to the neighboring Gingerbread Fancy restaurant, it matched its style in colors and lights, and both have remained at the park for more than 40 seasons. (Courtesy of GreatAdventureHistory.com.)

The Traffic Jam bumper cars were located near the geographic center of the park, very close to the Big Wheel and Flying Wave ride. When the Traffic Jam opened in 1974, it was the world's largest bumper car ride, and its popularity prompted the addition of a second bumper car ride for the 1975 season. (Courtesy of GreatAdventureHistory.com.)

The Swiss Bob, a longtime family favorite at Great Adventure, opened with the park in 1974. The ride appealed to riders of all ages, providing mild thrills as it raced through its banked turns. The ride may have been most memorable for the distinctive noise it made as the sleds raced around the metal rails, creating a sound that could be heard all around the park. (Courtesy of GreatAdventureHistory.com.)

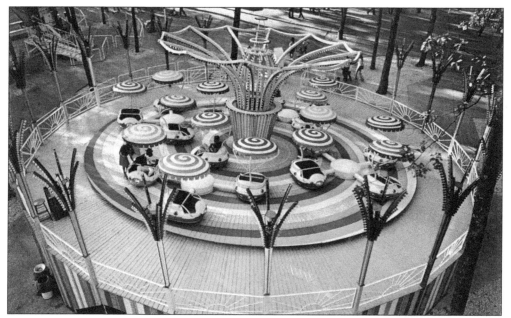

One of the most eye-catching rides at Great Adventure was the Calypso. The bright colors, motion, and tilted platform made it as much fun to watch as it was to ride. Initially, the ride was located right next to the Super Round Up, but after two seasons, it was relocated as the park's perimeters were expanded. The Calypso was removed to make way for the Condor in 1988. (Courtesy of GreatAdventureHistory.com.)

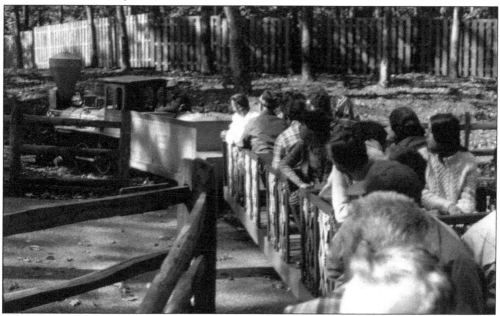

The Great Train Ride was a scenic ride behind a real-life steam train through the woods and along the lakes of Great Adventure. The four small trains were scaled down replicas of the trains that helped connect America in the 1800s. The 24-inch-gauge trains were built by Crown Metal Products Company of Wyano, Pennsylvania, and were removed after 1980 to make way for the addition of Roaring Rapids in 1981.

The Giant Wheel stood at the far end of Dream Street from the park's original entrance, drawing guests in further to explore the Enchanted Forest. At a height of 150 feet, the Ferris wheel was the world's largest when it was first operated and was purchased by Great Adventure after it served as the centerpiece of the Tulip Festival in the Netherlands. The ride is still a family favorite today. (Courtesy of GreatAdventureHistory.com.)

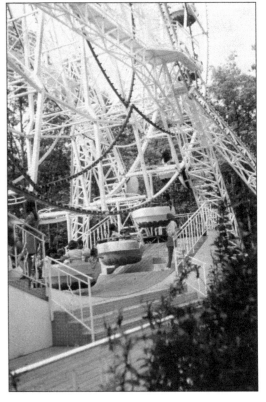

To help cope with the huge crowds, Great Adventure added the Fun Fair area for the 1975 season. Among the many rides, a second Ferris wheel, known as the Panorama Wheel, was introduced. This smaller wheel featured little round cars that originally spun, though they were welded in place after a short time. Early on, the ride was fitted with matching flower lights, just like those on the Giant Wheel. The ride was removed after 1996 to make way for Batman & Robin: The Chiller coaster. (Courtesy of GreatAdventureHistory.com.)

The Super Cat was a leased attraction that stayed at the park for just four seasons, from 1975 to 1978. It was brought to the park as a last-minute replacement for the Jumbo Jet coaster, which was assembled, never welcomed riders, and was removed within a few months in the summer of 1975. (Courtesy of GreatAdventureHistory.com.)

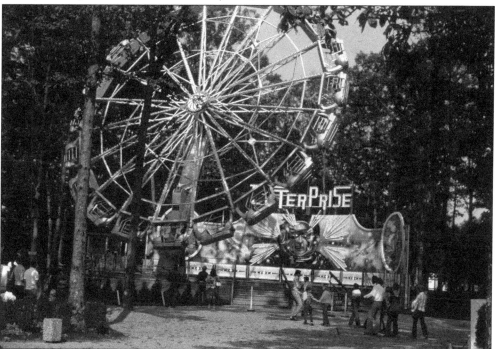

The Enterprise was a longtime fan favorite ride, and through the years Great Adventure was home to two different models. The first model, pictured here, operated from 1975 to 1977, and after a one-year hiatus, a second, updated park-model was installed in 1979. That version was later renamed Spin Meister and remained until the end of the 2006 season. (Courtesy of GreatAdventureHistory.com.)

Expanding attendance brought new rides rapidly for the first several seasons, with the latest ride designs including those from Europe being brought to Great Adventure. In 1976, a compact electric-powered roller coaster called the Alpen Blitz joined the ride lineup. This mild thrill ride remained until late 1978, when it was replaced by a haunted house attraction for Halloween, which was replaced the following year by the Haunted Castle attraction.

Also added in 1976, the colorful Musik Express ride was a crowd favorite from the Oktoberfest of Munich and featured a colorful, fast-paced ride by day or by night. It was also an employee favorite since it featured the latest hit music for that summer. Recorded music was provided by the park, but occasionally, ride operators would plug in their own music, which was not always appropriate for the family atmosphere of the park.

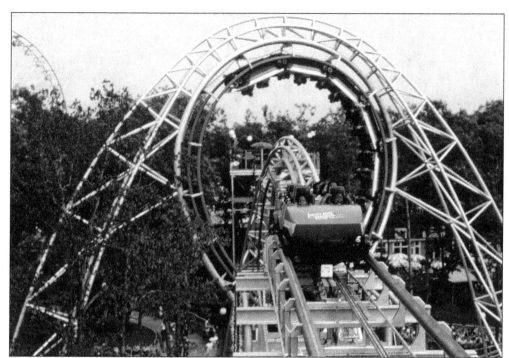

In 1978, Great Adventure unveiled its first major thrill ride with the introduction of Lightnin' Loops. Comprised of two separate launch coasters, these electrifying twin shuttle loops were the first addition to Great Adventure as a new member of the Six Flags family of theme parks. The ride remained at the park until the end of the 1992 operating season, when it was removed to make space for Batman: The Ride.

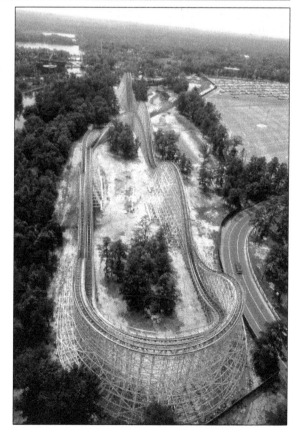

The 1979 season saw the addition of Rolling Thunder, Great Adventure's largest roller coaster at the time. The dual-tracked wooden racing coaster doubled the thrills, with two trains forging back and forth, vying to win the race into the station, with several points on the ride providing opportunities for the trains to pass each other as they battled.

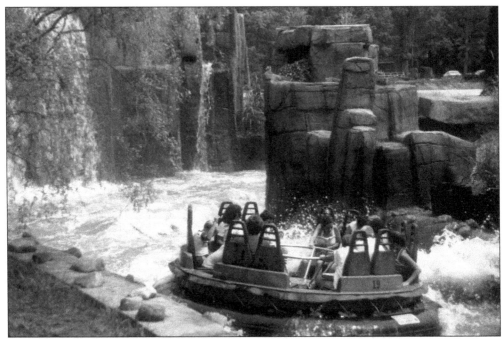

Water rides have always been some of the most popular attractions in the park, and the addition of Roaring Rapids in 1981 was no exception. Whitewater-rafting rides were created by Six Flags and ride manufacturer Intamin AG of Zurich, Switzerland. Roaring Rapids was the second one ever built and the longest operating one in the world.

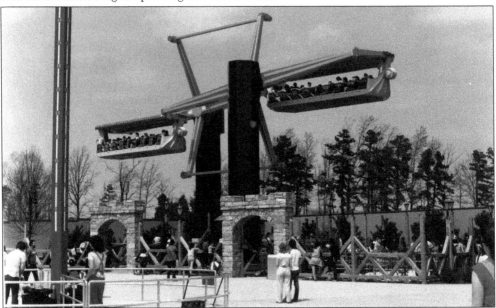

One of the most unique rides in Great Adventure's history was the Joust-A-Bout, a Schwarzkopf Chinese Junk ride. It was the only one of its kind in the United States and offered a unique stomach-flipping experience. The boats remained level throughout the ride cycle, causing an unusual dropping sensation when the ride rotated at high speeds. The ride opened in 1982 at the far end of the newly rebuilt Goodtime Alley games area.

60

Professional stuntman Dar Robinson was featured in a 1983 television commercial for the new FreeFall ride. The piece featured him jumping from a helicopter onto an airbag mounted on a barge in the East River, unphased yet screaming in fear while dropping down the 130-foot FreeFall tower. A decade later, in 1993, the ride was renamed Stuntman's Freefall as part of the newly themed Movie Town section. The ride was removed at the end of the 2006 season.

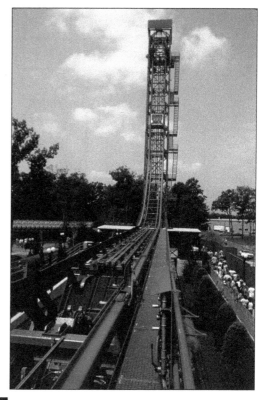

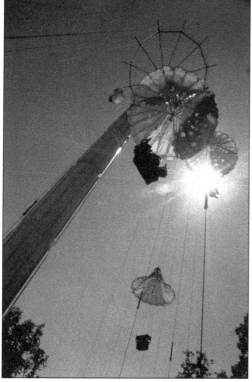

Parachuter's Perch was brought to the park in 1983 from its sister facility, Six Flags Over Mid-America near St. Louis, Missouri, where it operated as the Sky Chuter. Featuring eight independently operated parachutes, the ride stands 250 feet tall and is the only working large-scale parachute ride in North America today as well as the largest of its kind in the world.

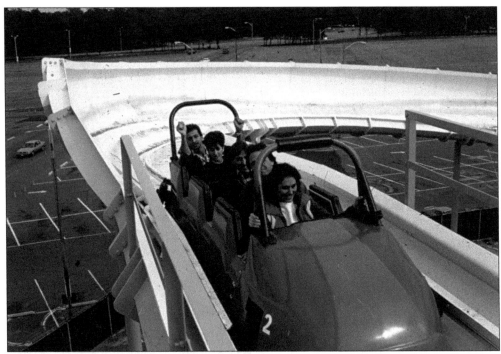

For the 1984 season, a new style of roller coaster, with a bobsled style track and cars, debuted. The ride was called the Sarajevo Bobsled, celebrating the XIV Winter Olympic Games held that year. As a promotion for the ride, guests who brought a snowball with them on opening day got into the park for free. The coaster was enjoyable and well received, but it proved temperamental since it could not run when it rained, let alone snowed.

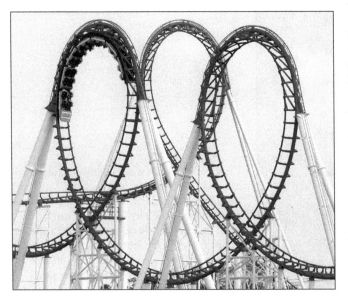

Operating from 1989 to mid-season 2010, the Great American Scream Machine was a workhorse in Great Adventure's roller coaster arsenal. With three appropriately colored red, white, and blue trains, the ride had a capacity of nearly 2,000 guests per hour. In 1994, the tops of the ride's three clothoid loops were replaced with reinforced track segments. One of the old loop tops was relocated to the safari's monkey section as a jungle gym. (Courtesy of GreatAdventureHistory.com.)

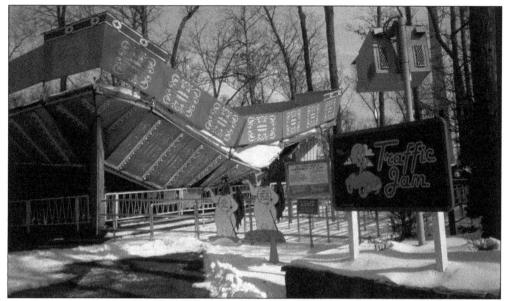

The Traffic Jam bumper car ride's lightweight structure was designed to be used either as a portable unit for fairs or as a permanent structure in parks. Just before the start of the 1993 season, a late-season snowstorm with heavy, wet snow fell on the canvas roof that had just been reinstalled for the start of the new season, crushing the structure beyond repair. The Autobahn bumper cars were added in 1994 as a replacement.

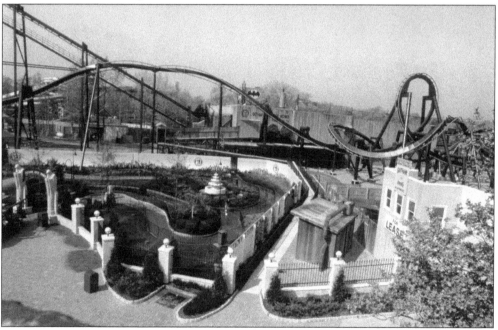

Also in 1993, Six Flags Great Adventure introduced Batman: The Ride. The state-of-the-art inverted coaster was one of the first in the world after the introduction of the model the previous year at Six Flags Great America. The roller coaster featured an immersive-themed queue area, taking guests through Gotham City Park and into the storm drains of the city, where one of Batman's many vehicles was ready to whisk them to safety.

One of the most memorable attractions in the park's history was the Right Stuff Mach 1 Adventure, a motion simulator theater added in 1994. The theater featured a giant screen and 100 motion-based seats that created the feeling of being in the movie. Over the years, the show changed several times with new films being added, including special ones just for Fright Fest. While the building still stands today, the simulator theater was discontinued after 2009.

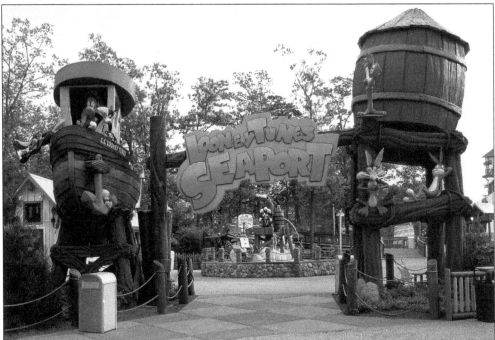

For the first time, in 1999, children had more than one area of the park set aside just for them with the introduction of Looney Tunes Seaport. Occupying the site that was previously home to Adventure Rivers, Looney Tunes Seaport kept the aquatic-related theme of the section and gave it a kid-inspired nautical flare.

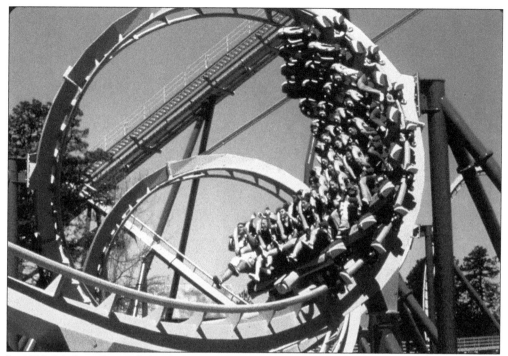

In 1999, Medusa changed the skyline of the park's western section, an area that went without any major additions for 25 years. The ride's creative backstory: the reason the snake-haired Greek monster was allowed to take up residence in a Western town was that she was supposedly banished to a gold mine, where brave guests challenged her, seeking fame and fortune. Medusa was transformed into Bizarro for 2009.

Consistently ranked as one of the best steel roller coasters, Nitro was added in 2001 to the delight of thrill-seekers. At a height of 230 feet and a length of 5,394 feet, this mega coaster pushed the boundaries of the theme park, utilizing remote portions of the Six Flags Great Adventure property while offering a nighttime ride into near total darkness. (Courtesy of GreatAdventureHistory.com.)

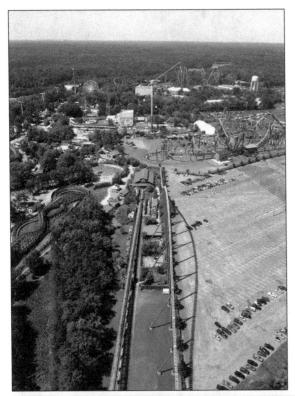

Kingda Ka offers riders just a brief glimpse of the world around them at the top of the 456-foot tower before plunging straight down back toward earth. On a clear day, the skyline of Philadelphia is visible from the crest of the ride, and the view of the world's largest theme park is breathtaking.

At the heart of Kingda Ka is a massive hydraulic motor, accelerating trains up to 128 miles per hour to get up and over the ride's record-breaking tower. Occasionally, the speed needed is not quite achieved, resulting in a "rollback," where the train travels backwards to the starting point, and the whole system resets and tries again.

To date, two wooden coasters have been able to call Six Flags Great Adventure home. Rolling Thunder roared around its dual-track rails from 1979 to 2013, and El Toro has been charging through its layout ever since 2006. The intertwined designs of these two rides was an impressive site, with a total of nearly 11,000 feet of twisting roller coaster track. (Courtesy of GreatAdventureHistory.com.)

The thrills at Six Flags Great Adventure have always been reaching to new heights each season. In 2012, the SkyScreamer took the concept of the original Flying Wave swing ride 242 feet up, soaring almost 100 feet above the Big Wheel, which had been the tallest structure in the park for many of its earliest years. (Courtesy of GreatAdventureHistory.com.)

The New Jersey Devil has always been a favorite piece of folklore for the state, and in 2015, guests reported sightings of him with the introduction of El Diablo. This looping thrill ride, in the Plaza del Carnaval section of the park, offered a new "in between ride" for those who were too young for the big coasters and too old for the kiddie rides.

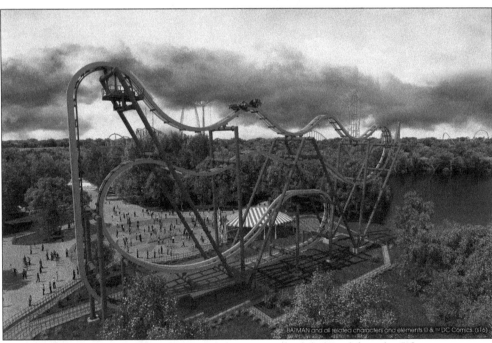

BATMAN and all related characters and elements © & ™ DC Comics. (s16)

For the 2016 season, Six Flags Great Adventure is scheduled to debut the Joker, an exciting free-spinning fourth-dimension roller coaster. The unique compact design packs a lot of punch, with no two rides being exactly the same. The new coaster is planned to be front and center in the park, taking the place of the old Aqua Spectacle arena, directly past the Fountain near the main entrance.

Four

SO MUCH TO DO, SO CLOSE TO HOME

Six Flags Great Adventure has always been so much more than just rides and shows. Around every corner and inside every building, the park has offered a wide variety of entertaining options to appeal to a wide audience, from the very young to the most senior guests.

For diners, it has been a banquet of food, from picnic baskets in the early years to the introduction of the Season Pass Dining Plan today. It has been the opportunity to have a quiet lunch on the patio of the Best of the West restaurant or having dinner at Granny's, knowing that the designer of the restaurant also created the infamous Tavern on the Green. It is picking up a snack that a theme park is known for, like cotton candy, a churro, or a funnel cake.

The shopping options have always been diverse at Great Adventure. Only here could visitors buy an authentic Indian headdress at the Super Teepee, a hand-blown glass sculpture crafted before their eyes, or a Great Adventure souvenir from a day of fun at the park. Based on game skills, one could bring home a winning prize to proudly display, such as a small pin-back button or an oversized plush bear with a rainbow logo on its shirt that had to be strapped to the car's rooftop because it was too big to fit inside.

Special events throughout the year have meant that no two visits were ever the same. Whether it was the first rides of the spring when the park reopened after a long winter slumber, special events like the New Jersey State Fair, the coming of fall and Fright Fest, or the celebrations of the winter season with Holiday in the Park, there has always been something new, fun, and exciting going on in the park.

Most importantly, Six Flags Great Adventure has involved people: from the family and friends who made a day at the park special, to the safari warden who kept the bears off cars or the greeter at the main gate who welcomed visitors to the theme park, the ride operator who gave a coaster train the all-clear, the sweeper who followed guests around picking up the popcorn, and the thousands of other employees both backstage and onstage who helped make a day at Six Flags a Great Adventure.

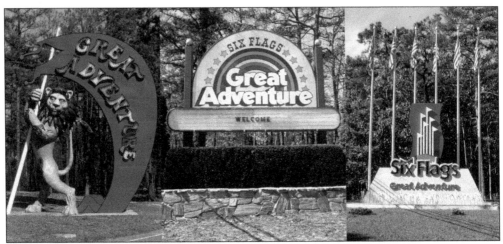

The entrance road for the park on Route 537 has been home to three different signs over 40 years. The original lion sign was replaced with the Six Flags rainbow logo in the late 1970s, and then in the 1990s, the current sign was erected. The sign reflected the new emphasis by Six Flags to create a more unified and recognizable brand for all the parks the company owned, stressing the Six Flags brand over the Great Adventure name.

On what appears to be a chilly fall day, the ticket takers stand at the turnstiles at Great Adventure's original entrance. This entrance only served for two seasons before the larger central entrance plaza was built in 1976. The original entryway just proved to be too small for the crowds, and the new entrance at the fountain improved the flow of guest traffic in the park. (Courtesy of Dennis Gilbert.)

An early icon for Great Adventure was a hot-air balloon that both served as an attraction and was used for promotional events outside the park. The park was home to both a standard-size balloon and a "giant" balloon, which was billed as the world's largest. The landing field, Balloonland, was located next to the Garden of Marvels, an intricately detailed miniature village depicting some of the world's best-known architecture. (Courtesy of GreatAdventureHistory.com.)

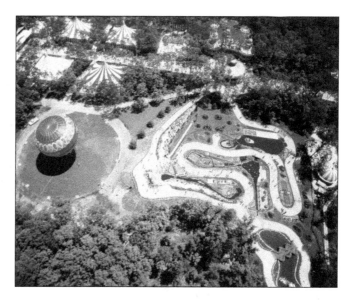

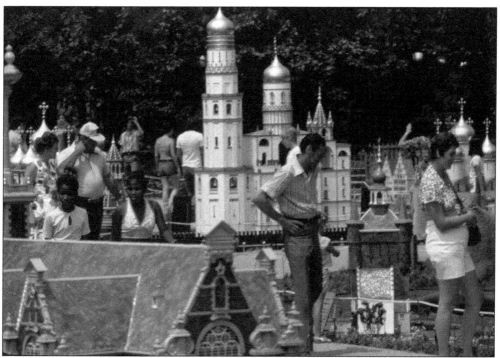

Guests could take a relaxing stroll through the Garden of Marvels and its collection of model buildings from around the world. The structures, created by Arthur Thuijs from the Netherlands, were incredibly detailed. Cars, trains, and boats all traveled around through the area that was filled with waterways and framed by a man-made mountain range. (Courtesy of GreatAdventureHistory.com.)

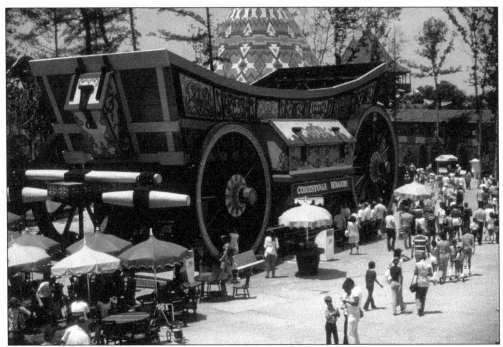

The idea for an oversize Conestoga Wagon dates back to the original plans Warner LeRoy designed for Great Adventure, a place where everything was magically presented in a larger-than-life way. The initial renderings for the wagon included a cloth-enclosed bonnet and a pair of steadily positioned oxen, which were never added. The refreshment stand was removed in January 2013 for construction of the Safari Off Road Adventure loading station. (Courtesy of GreatAdventureHistory.com.)

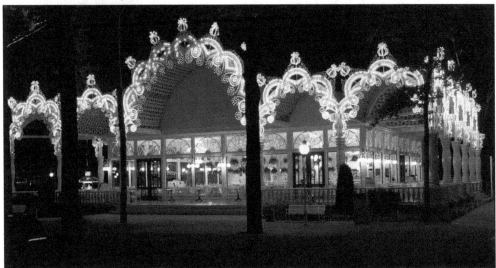

Gingerbread Fancy was one of Great Adventure's three main restaurants when the park opened in 1974. All three featured unique architecture, but only Gingerbread Fancy became more impressive after dark, with its scrolls of thousands of multicolored lights on the arches around its patio. The interior was equally elaborate, with graceful scrolling bentwood columns covered with hanging baskets of ferns. (Courtesy of GreatAdventureHistory.com.)

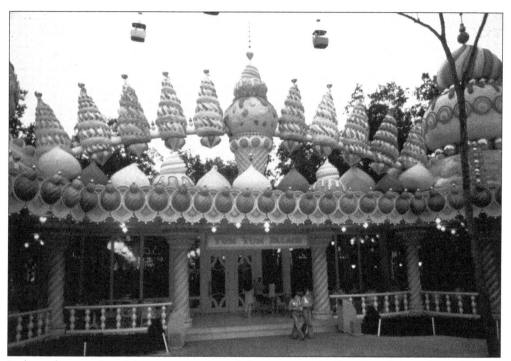

Perhaps the most fanciful structure at Great Adventure was the Yum Yum Palace. When Warner LeRoy designed the park, he envisioned many buildings looking like giant versions of what they sold. The colorful fiberglass scoops of ice cream and dollops of whipped cream left nothing to the imagination about the treats awaiting inside.

The interior of the Yum Yum Palace was just as ornate as the exterior. The colorful candy cane columns found around the patio continued inside with fans of mirrors at the ceiling in matching colors. The menu was done like an old-fashioned ice-cream parlor, with oversized mirrors painted with the descriptions of all the sweet offerings.

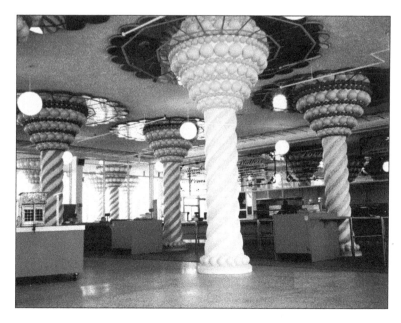

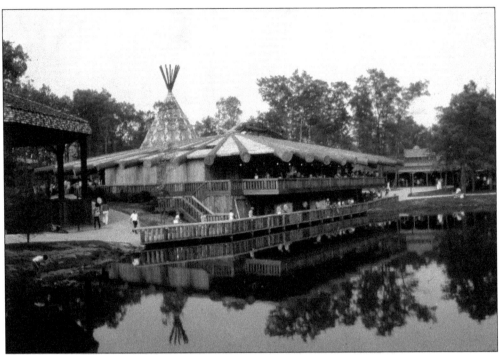

Many theme parks use forced perspective to make things seem bigger than they are, but Great Adventure took the opposite approach, especially in the Western-themed Rootin' Tootin' Rip Roarin' area. Everything was built on a huge scale, larger than life. For example, the Best of the West restaurant was erected using timber-frame construction techniques with enormous logs. In 1974, the building was the most expensive structure in the park, costing over $2 million alone.

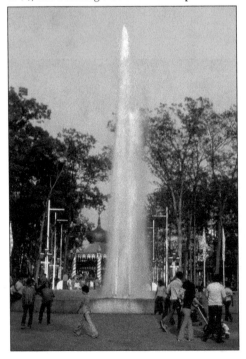

Further down Dream Street was the Fountain, which was billed as the world's tallest fountain jet when the park opened. The Fountain was spectacular, but with the slightest wind, crowds would end up getting wet. The configuration of the Fountain was eventually changed, with a smaller center jet and a ring of other nozzles, as well as fencing around the edge to keep guests out. The Fountain was redesigned in 1994. (Courtesy of GreatAdventureHistory.com.)

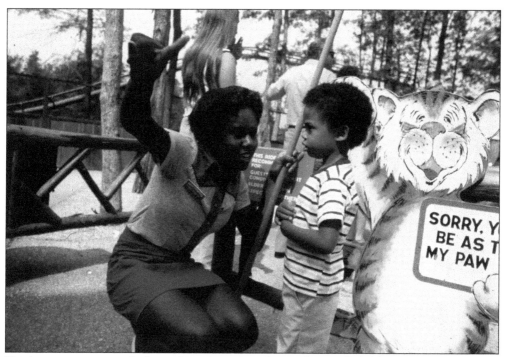

Height restrictions on rides have always been a regulation that small children needed to deal with when visiting Great Adventure. During the park's first several seasons, animal-themed height indicators, like the tiger cutout at the entrance to the Runaway Mine Train, shared the bad news: "Sorry, you have to be as tall as my paw to ride." (Courtesy of GreatAdventureHistory.com.)

Throughout Great Adventure, carts selling a variety of sweet temptations have always been a part of the landscape. Whether it was candy, Italian ice, drink sippers, cotton candy, popcorn, or Dippin Dots, a fleet of carts has always been there to fill the gap between meals and to encourage everyone to have a tasty snack as part of a day at the park.

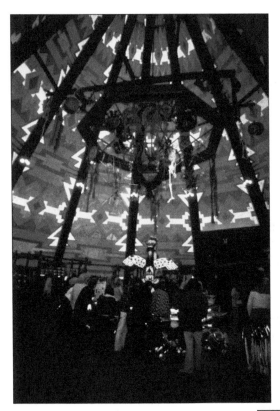

Supported by 12 gigantic logs brought in from the Yukon Territory, the Super Tee Pee was no friend to the harsh New Jersey winters. Winds ripped the canvas walls of the shop to shreds during the winter of 1974–1975, transforming it into an open-air bandstand for part of the 1975 season. During the winter of 2007–2008, another storm destroyed the canvas again, and with the deteriorating condition of the 34-year-old logs, the decision was made to remove this landmark structure. (Courtesy of GreatAdventureHistory.com.)

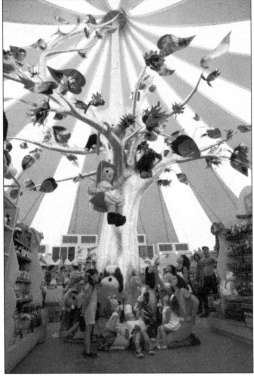

The four tent buildings that served as Great Adventure's main gift shops were all spectacular and unique. For many, the most memorable was Fairy Tales, which featured a huge array of stuffed animals and fanciful toys. At the center of the shop was a huge silver tree with colorful metallic foliage that cast a rainbow of reflections all around the shop. (Courtesy of GreatAdventureHistory.com.)

The shops of Great Adventure have sold a wide variety of merchandise over the years. From the usual selection of T-shirts and souvenirs to high-end jewelry, dolls, and crystal, the stores have always changed with the fluctuating tastes and styles of the public. Pictured is the interior of the Declaration of Gifts shop, which had a very formal feel in the mid-1990s but specializes in M&M's merchandise today.

Main Street Market was designed to showcase Looney Tunes merchandise, Warner Bros. products, and Six Flags Great Adventure branded souvenirs. It was added near the park's main entrance in 1994. At the time, Warner Bros. stores were found in major shopping districts and malls, and the park featured many of the same or similar products.

Great Adventure has had about a half dozen shooting galleries over the years. The first was the Western Shootout, which was located next to the Log Flume and Super Teepee. Because of its popularity, it was soon joined by others, including the Safari Shootout, the Para Shooter, and Chicago Shootout. (Courtesy of GreatAdventureHistory.com.)

Prizewinning games of skill first debuted in 1975 with the addition of the Fortune Festival games center. Approval for games such as coin-tossing, dart-throwing, ring-tossing, Skeeball, balloon-busting, pin-bowling, and doll knock-downs was granted by Jackson Township in March 1975, with a restriction that there would not be any games that could be considered gambling, such as wheels of chance.

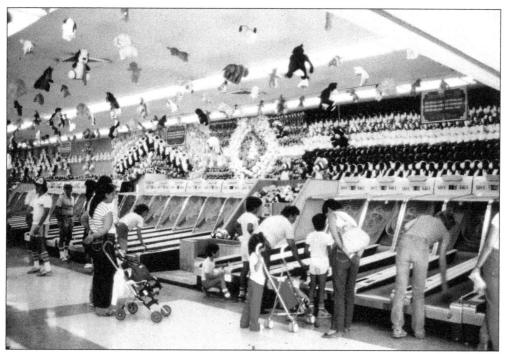

The Skeeball Barn was added in 1978 next to the new Lightnin' Loops roller coaster. Guests were presented with nine balls and challenged to roll each one down an alley at targets ranging from 0 to 50 points each. A minimum score of 250 would result in winning a small plush prize, and higher scores won larger stuffed animals. Today, the former Skeeball Barn is the Studio 28 Arcade.

Built in 1979 alongside Rolling Thunder, the Hernando's Hideaway games area offered a second centralized location in the park for guests to test their skills in the hopes of winning a stuffed bear or similar trophy. The added revenue Hernando's provided inspired further expansion in the following year with the addition of another games stand named Pedro's Pitch.

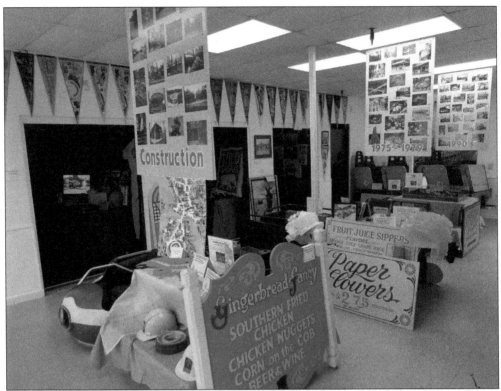

The Great Adventure History Museum was a temporary exhibit that displayed park historical information and artifacts during July 2014 and for a brief encore during the American Coaster Enthusiasts' Coaster Con in June 2015. GreatAdventureHistory.com was honored to assist with this well-attended attraction, which was only made possible by the driving force and direction of Dory Oswald, the park's special events manager. (Courtesy of GreatAdventureHistory.com.)

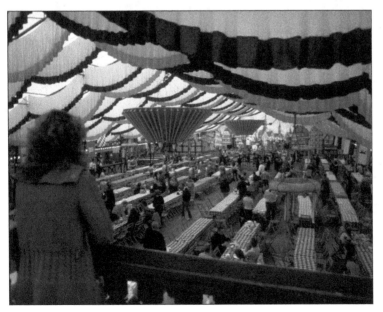

Great Adventure has always been adding new entertainment and events to extend its season. In 1980, Great Adventure shipped an authentic Fest Halle from Munich to celebrate Oktoberfest. With its music, food, dancing, and of course, beer, the event was such a success that the next season, the temporary structure was replaced with a permanent Fest Haus, which is still in use for park events today.

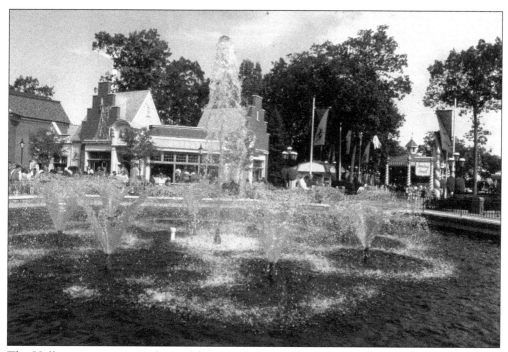

The Halloween season was first celebrated at Great Adventure in 1978 with the introduction of Halloweekends, which was promoted on and off until 1992 when Fright Fest debuted. With a mixture of horrific decorations, unique bone-chilling attractions, and some longtime favorite shows, Fright Fest is today one of the busiest events of the entire season.

Dead Man's Party has become a staple of Fright Fest since its premiere in the fall of 1999, thanks to its loyal fans who flock to each performance. This lively show, with its deadly cast, conjured up ghoulishly good fun at the base of the Big Wheel through the 2011 season, when the entire production was reincarnated in Movie Town on a temporary stage just outside of the Batman Stunt Arena.

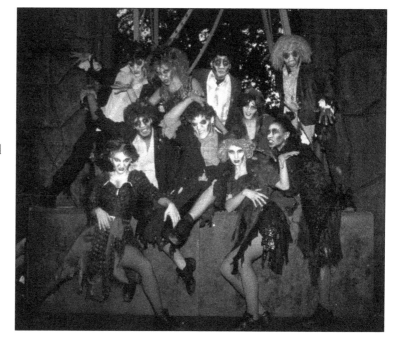

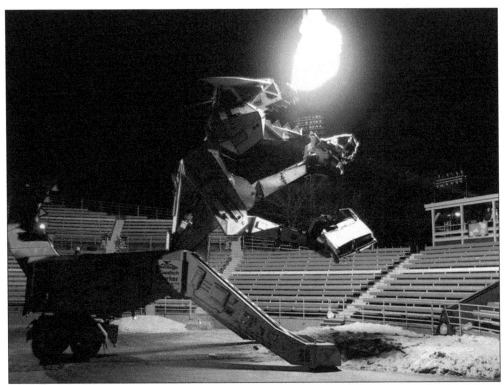

Over the years, several unique entertainment offerings have been thrown into the Fright Fest entertainment mix to make the Halloween event even more frightful. Robosaurus, the monstrous fire-breathing and car-eating contraption, thrilled guests in the park's Northern Star Arena during 2001, a year when less of a focus was put on gruesomeness and the macabre of Halloween, given the recent events of 9/11. (Courtesy of GreatAdventureHistory.com.)

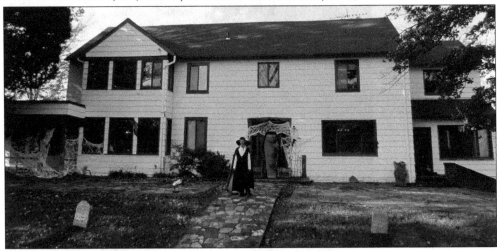

In 2011, guests were invited to travel into the heavily wooded lakeside areas of Great Adventure's property where they would encounter a cast of classic monster characters aboard the Haunted Wagon Tales hayride. The 30-minute journey even ventured past Dracula's Manor, which was actually once the stately home of the Switlik family, the original owners of the land upon which Great Adventure was developed. (Courtesy of GreatAdventureHistory.com.)

In 2010, Six Flags Grape Adventure, an event that gathers locale wineries and vineyards for a festival in the park's catering area the weekend after the regular operating season, was introduced. Even though all the park's coasters and rides are closed during the event, the popularity of Grape Adventure served as the inspiration for extending the season by introducing Holiday in the Park. (Courtesy of GreatAdventureHistory.com.)

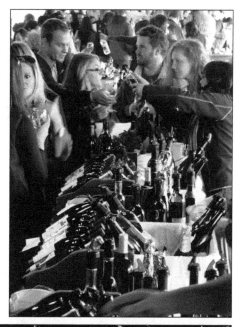

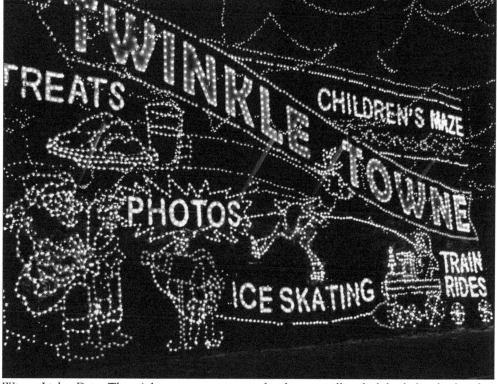

Winter Lights Drive-Thru Adventure was a spectacle of over a million holiday lights displayed in over 200 different designs viewed from the comfort of guests' own cars during the 2002 and 2003 postseasons. The nearly three-mile route made its wandering way through Great Adventure's parking lots, past glowing animated displays, culminating in holiday-themed food and the entertainment center near the theme park's entrance. (Courtesy of GreatAdventureHistory.com.)

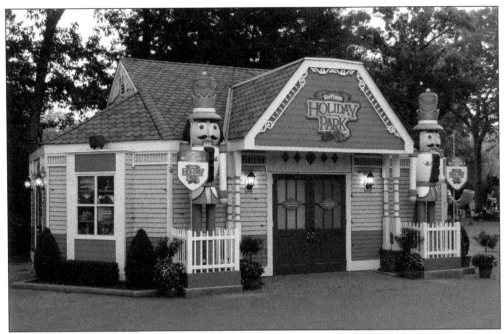

In 2015, the park's operating season was extended for the first time all the way to the new year as Six Flags' popular Holiday in the Park event was introduced at Great Adventure. Installation of more than a million miniature Christmas lights along with a festive Santa's House started to magically appear in early August, hinting at all the spectacle that was yet to come. (Courtesy of GreatAdventureHistory.com.)

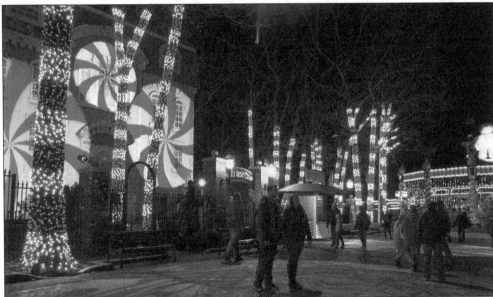

The majority of the theme park is transformed during Holiday in the Park into festive realms, including Gingerbread Junction, Polar Point, Treetop Summit, Snowman City, and Poinsettia Peak. Not only can guests take in all the seasonal specialties and entertainment found in each area, but they can also enjoy some of their favorite rides and coasters while counting the days until Christmas and into the New Year.

Five

THREE WORLDS
OF ADVENTURE

Plans for Great Adventure always envisioned it being much more than just a theme park. For much of the park's history, the theme park and Wild Safari operated side by side, providing guests with the opportunity to see exotic wildlife and enjoy wild rides all in the same visit.

The Wild Safari was the world's largest safari park outside of Africa from the day it opened in 1974 until the day it closed in September 2012. The park housed more than 1,200 animals, from dozens of species and six continents. The safari was carefully planned to utilize the existing terrain and features of the land to try and replicate the native lands of the various animals as closely as possible. Working with a global network of other zoos and animal parks, the safari park participated in breeding programs to help preserve and protect endangered species.

For the 2013 season, the safari was incorporated into the theme park with the addition of the Safari Off Road Adventure. The combination of the two parks made Six Flags Great Adventure the world's largest theme park in area and created a new and unique experience for guests. While guests used to drive their own vehicles to see the animals, now they boarded special all-terrain vehicles that allowed them to get closer and learn more about the amazing menagerie.

In 2001, Six Flags Hurricane Harbor water park was added to the property, creating an enormous world-class water park set in a lush tropical oasis. Over the years, Hurricane Harbor has continued to add new attractions to make an already exciting park into a full day of splashy fun. Together with Six Flags Great Adventure, the Six Flags New Jersey complex offers a huge lineup of wet and wild fun and excitement.

Site design and preparation for the Wild Safari park took over a year, with most of the natural terrain and vegetation used when possible. Tree selection, grass planting, man-made lake excavation, and special underground irrigation system installation—not to mention the construction of nearly five miles of roadway—all had to be carefully planned before the first animals could be delivered to the park.

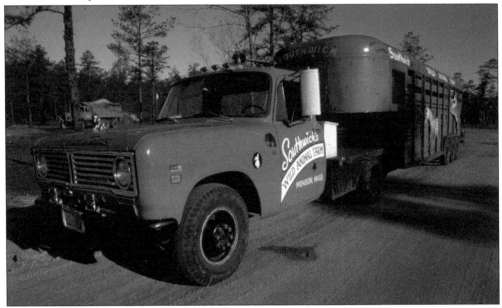

The huge collection of animals for the Wild Safari park was acquired from around the world. Some of the animals came from other safari parks and zoos throughout North America, while others were imported from South America, Europe, Asia, Australia, and Africa. Each species was carefully placed and methodically released into a habitat that it would soon call home.

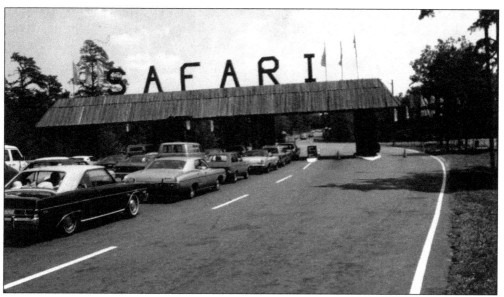

Quite often, guests opted to visit the Wild Safari park prior to heading into the theme park—especially since the animal park typically opened up to an hour earlier each morning. Long lines of cars full of anxious visitors would usually stack up outside of the Wild Safari ticket gate, often regulated by the flow of traffic into the crowded savannas.

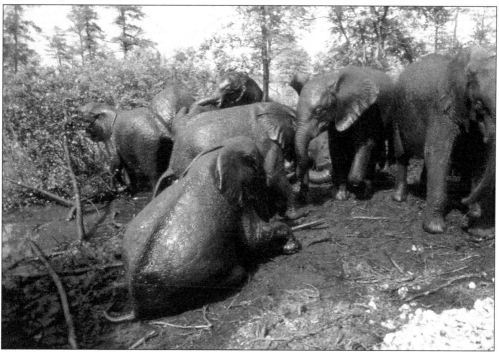

The number of animals that were imported to the Wild Safari park was astounding, including 28 elephants, almost 20 rhinoceroses, and over 50 ostriches, which all shared a habitat that included specially created mud lakes and climbing mounds made of imported featherock from California. Until 1978, there were not any barriers preventing the elephants from entering the roadways. Safari wardens were stationed on foot to keep them off the roads.

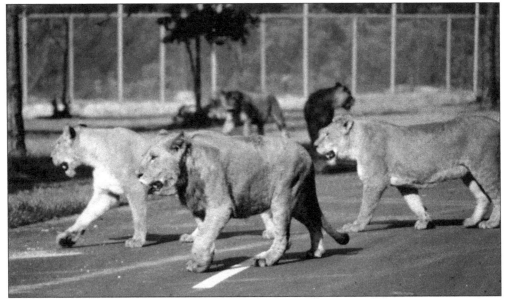

The big cats were always a highlight of a trip through the Wild Safari park. Originally, the lions and tigers were free to roam throughout their habitats and approach and often climb on top of passing cars. In 1988, fencing was added that separated the felines from the vehicles. Other cats such as leopards and panthers made brief appearances at the park, but they were always segregated from visitors.

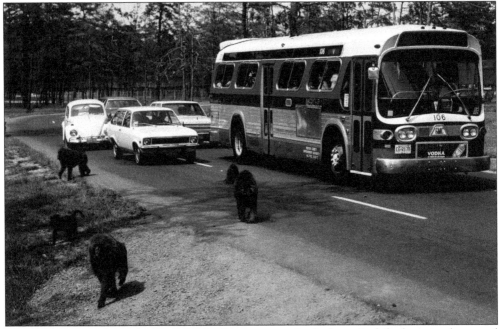

The Wild Safari park was designed so that the guests were in the "cages" while the animals roamed free. The baboons were especially fond of riding on vehicles and would often rip off windshield wipers and other loose auto trim. Vinyl-top cars were especially vulnerable because of the glue used by automakers, which contained a banana extract. This ongoing "monkey business" led to the creation of the Baboon By-Pass road around the area, so car owners could avoid costly damage.

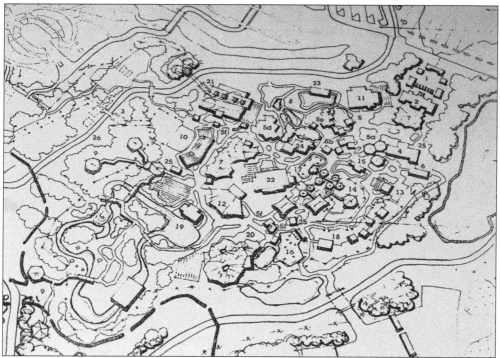

Always looking on ways to improve Great Adventure, plans for a proposed jungle-inspired theme park on the site of the monkey section of the Wild Safari park were drafted. In addition to keeping the drive-through safari, the new park would have included animal exhibits and trails, multiple shows, a petting zoo, and numerous rides such as an African Diamond Mine Coaster, Lost Temple Dark Ride, and Jungle Boat Adventure.

On September 30, 2012, at 6:29 p.m., the Wild Safari gates closed for the last time after the final cars exited the park. The era of the drive-through experience was over, and the next season would allow guests to see the safari park in an entirely new way. (Courtesy of GreatAdventureHistory.com.)

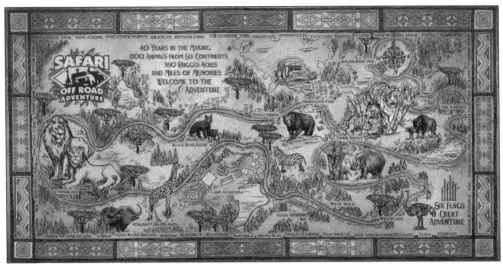

What had been the Six Flags Wild Safari, the world's largest drive-through safari park outside of Africa, became the Safari Off Road Adventure in 2013. During this new experience, guests would journey through a preserve owned by the fictional Wilds family, who have gathered an amazing collection of animals from around the world and brought them to New Jersey.

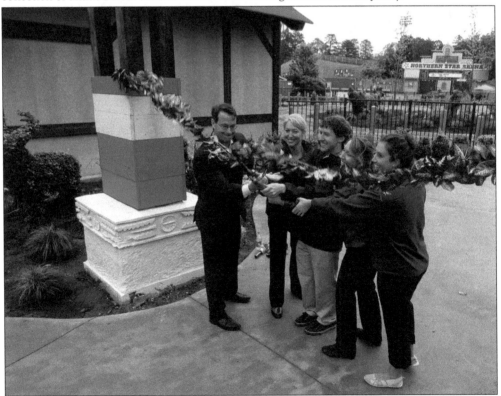

On May 24, 2013, park president John Fitzgerald and members of his team cut the ceremonial vine to open the new Safari Off Road Adventure tour to the public. With the transition of the safari from a separate park to part of the theme park's attraction lineup, Six Flags Great Adventure became the "World's Largest Theme Park." (Courtesy of GreatAdventureHistory.com.)

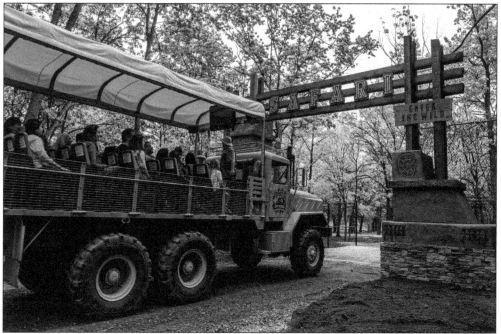

For the 2013 season, Six Flags Great Adventure combined the theme park with the Wild Safari park. The Safari Off Road Adventure replaced the guest drive-through aspect of Wild Safari, with a guided tour on specially designed open-air trucks, bringing visitors even closer to the park's hundreds of wild animals.

As part of the makeover of Wild Safari into the Safari Off Road Adventure, a new outpost was added in the heart of the safari called Camp Aventura. This new midpoint stop-off allowed guests to get even closer to some animals through educational exhibits and informative animal ambassadors. (Courtesy of GreatAdventureHistory.com.)

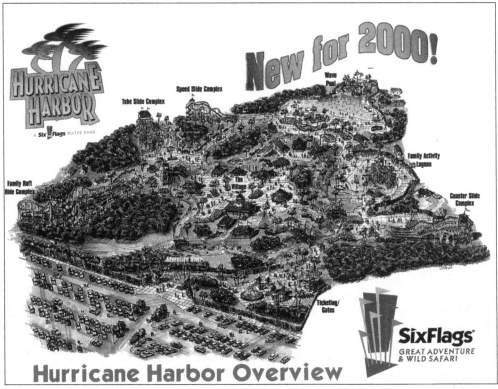

New for 2000!

Hurricane Harbor Overview

Hurricane Harbor became Great Adventure's third gated park in 2000. Its central island, known as the Village, contains most of the park's retail and guest service facilities and is completely surrounded by a lazy river named Taak It Eez Ee Creek. The original plan was for the river to be called Adventure River as a tribute to the water-slide area once found inside Great Adventure's theme park, which was removed one season prior to Hurricane Harbor's opening.

Hurricane Harbor was designed with a detailed backstory that included fictitious characters and imaginative inventions that could all be found in the props and attractions placed around the park. This high level of theming helped create a destination that was much more than just a water park—it was an escape to a tropical oasis.

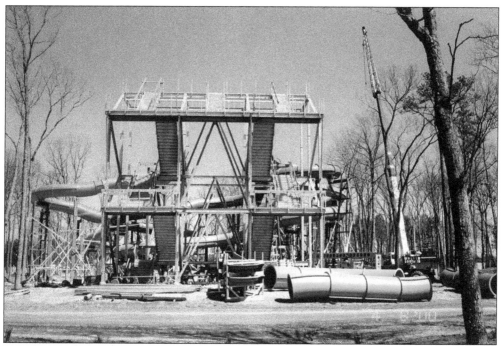

Initial ground clearing for Hurricane Harbor started during the summer of 1999, followed by excavation of the park's wave pool and lazy river during early 2000. By the time the theme park opened that season, vertical construction of the park's facilities and water slides was well underway, with pieces of the soon-to-be assembled attractions dotting the outskirts of the neighboring parking lots. (Courtesy of GreatAdventureHistory.com.)

Just like the shipwrecked passengers on *Gilligan's Island*, visitors to Hurricane Harbor found themselves in the heart of a far-off paradise. As part of the grand-opening ceremonies, several original members of the cast of the TV classic were on hand to cut the ribbon of Great Adventure's new water park, including, from left to right, Bob Denver (Gilligan), Dawn Wells (Mary Ann), and Russell Johnson (the Professor).

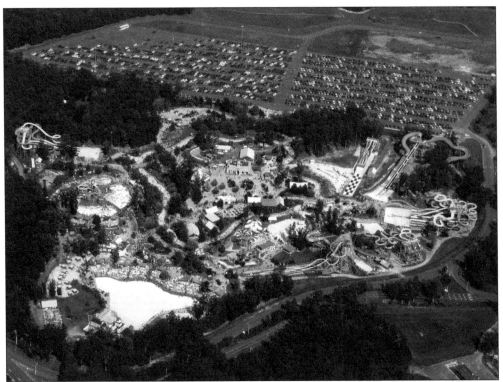

Occupying 45 acres east of Great Adventure's main entrance roadway, Hurricane Harbor was constructed on a plot of land that was earmarked for a once-imagined minor league baseball stadium some 10 years earlier. As Hurricane Habor is a separate gated facility situated on the opposite side of the theme park's parking lot, shuttle bus service is provided between the two gates for guests wishing to visit both parks. (Courtesy of Phillip Kineyko at FlyinPhilsPhotos.com.)

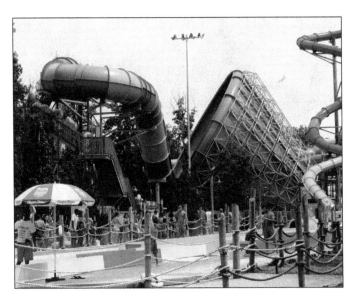

To mark Hurricane Harbor's 10th anniversary, the Tornado slide was added in 2010, offering guests a chance to careen down a dark, enclosed slide into a massive funnel shaped structure. The ride was carefully positioned near Great Adventure's main entrance way to catch the eyes of those guests heading toward the theme park. (Courtesy of GreatAdventureHistory.com.)

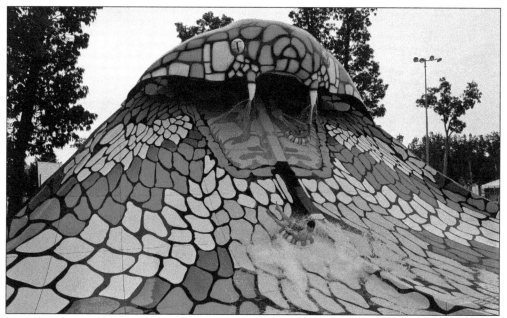

Six Flags Great Adventure has always been an innovator, bringing in the latest and greatest rides from around the world. Even Six Flags Hurricane Harbor has worked to bring new and exciting slides like the unique King Cobra, the first ride of its kind in North America. This colorful snake-shaped attraction offered an intimidating new twist on water slides.

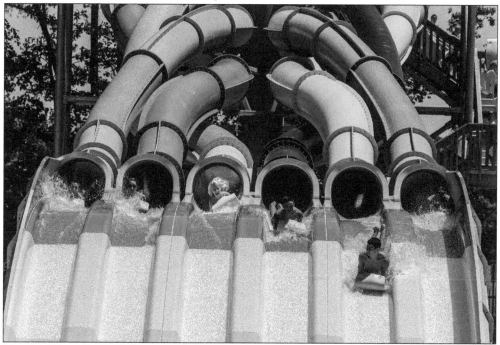

The Big Wave Racer slide was added to Six Flags Hurricane Harbor in 2013 as a new thriller where guests could race one another to the bottom headfirst on mats. New additions like this water slide and annual investments in the theme park are what helps keep Great Adventure fresh and new year after year and guests returning season after season.

Visit us at
arcadiapublishing.com

CPSIA information can be obtained
at www.ICGtesting.com
Printed in the USA
BVHW011219191122
651984BV00039B/355